TRISTAN & YSEULT

THE BACCHAE
THE WOODEN FROCK
THE RED SHOES

D1388449

Kneehigh Theatre

TRISTAN & YSEULT

THE BACCHAE
THE WOODEN FROCK
THE RED SHOES

OBERON BOOKS
LONDON

First published in 2005 by Oberon Books Ltd
521 Caledonian Road, London N7 9RH
Tel: 020 7607 3637 / Fax: 020 7607 3629
e-mail: oberon.books@btconnect.com
www.oberonbooks.com

A catalogue record for this book is available from the British Library.

ISBN: 1 84002 564 6

Cover photo by Steve Tanner, Lephoto.com

Front cover: Tristan Sturrock and Éva Magyar

Printed in Great Britain by Antony Rowe Ltd, Chippenham

This book is for Bill Mitchell under whose passionate and inspired Artistic Directorship these shows were produced.

Contents

Foreword

Kneehigh is, and always has been, a team.
We have been telling stories for twenty-five years.
In this volume are four of the stories we have told over recent years.
It is made with thanks to all who have made Kneehigh the brave, innovative and generous company it is today.

To start…

There is no formula to the way we make theatre. However, it always starts with the story. No, it starts before then. It starts with an itch, a need, an instinct.

Each story in this collection started with an itch. Each one is raw, relevant and personal. Stories have an ability to present themselves, to emerge as if from nowhere. But they never are from nowhere. This is the seminal moment of instinct. This is when your subconscious stakes its claim and intervenes in your carefully ordered life. I sit up when a story taps me on the shoulder. I respect coincidence. I listen to impulse. One of my most hated questions when making theatre is: why? 'Because,' I want to answer. 'Because…'

For me, making theatre is an excavation of feelings long since buried, a journey of understanding. Bruno Bettelheim in *The Uses of Enchantment,* his book about children's relationship to fiction, states that 'our greatest need and most difficult achievement is to find meaning in our lives'. He argues that by revealing the true content of folktales, children can use them to cope with their baffling and confusing emotions.

My fascination with certain stories is fuelled by my own subconscious. *The Red Shoes* charts the pain of loss, obsession and addiction; *The Wooden Frock* follows the slow and faltering healing process; *Tristan & Yseult* is a poem to love and its madness; and *The Bacchae,* a terrifying glimpse at the

11

beast in us all. These are not children's themes but I often approach them in a childlike way. In my experience, our basic needs and desires are the same – to be communicated with, to be delighted, to be surprised, to be scared. We want to be part of something and we want to feel. We want to find meaning in our lives.

The event of live theatre offers a rare opportunity to satisfy all of these needs. We can have a collective experience, unique to the group of people assembled in the theatre. I don't want 'the fourth wall' constantly and fearfully placed between the actors and their audience. I want the actors to speak to their accomplices, to look at them, to respond to them. I want a celebration, a collective gasp of amazement. I want the world to transform in front of the audience's eyes and demand that they join in with the game. Theatre is nothing without the engagement of the audience's creativity. Theatre takes us right back to Bruno Bettelheim and his belief in the therapeutic and cathartic nature of stories. We tell them because we need them.

To continue…

Months before rehearsals begin, I start work with the creative team. Bill Mitchell (designer) and I gaze at books and films, sketch and begin to form a concept; an environment in which the story can live, in which the actors can play. This physical world holds meaning and narrative. It is as much a story-telling tool as the written word. Stu Barker (musical director and composer) and I exchange music that inspires us or just feels right. We talk of themes and feelings. From these conversations he creates a musical palette of melodies and soundscapes. With the writer or writers, we talk and dream. We map out the structure and the overall shape of the piece. They go away and write collections of poems or lyrics or ideas. Each writer works in a different way but what none of them do is to write a script or a scene in isolation.

It is this fertile palette of words, music and design that we bring to the rehearsal room. As I said, Kneehigh is a team. The shared imagination is greater than any individual's, so we begin the rehearsal process by returning to the story. We tell it to each other, scribble thoughts on huge pieces of paper and relate it to our own experience. We create characters, always looking to serve and subvert the story. Actors like Mike Shepherd and Craig Johnson delight with their deft improvisation, breathing life and naughtiness into the bones of the story. Performers like Bec Applebee and Éva Magyar use their painfully eloquent bodies to create physical poetry and story. Giles King and Tristan Sturrock tickle and disarm with their tragic clowns. Stu's music is used to help create the world, to guide and inform improvisation and to release feeling. Lighting is used from day one. The design is developed with ideas coming from the devising team. The writers are in rehearsal. They watch and inspire, feeding in their poetry, their lyrics. They respond to improvisation and craft scenes and characters alongside the actors. Layer upon layer the world is created, the story released.

We lay the foundations, then we forget them. If you stay true to the fundamental relationship between yourself, your team and the subject matter, the piece will take on a life of its own. Armed with instinct, play and our building-blocks of music, text and design, Kneehigh do fearless battle. One of our most used phrases in the process is 'hold your nerve'. There is no room for neurosis or doubt, these will only undermine the process; hold your nerve, stay open and delight in the privilege of making theatre.

To end…

In this volume, I hope you will find poetry that is simple and truthful; lyrics, soulful and witty; dialogue, surprising and sharp. Each writer – Anna Maria Murphy, Carl Grose and Tom Morris – bring their own beautiful and distinctive

voice to the work. But remember, these texts represent just one layer of the worlds that Kneehigh creates. As you read, close your eyes from time to time. Let a tune drift back from your childhood or recall a painting that made your heart pound. Remember falling in love or losing control, leaving a loved one or laughing until you cried. Now the work lives. Now there is a connection. Now there is meaning.

Emma Rice – Artistic Director, Kneehigh Theatre

TRISTAN & YSEULT

Foreword: *Tristan & Yseult*

I've always been good at love. I fell head-over-heels at fifteen and was hooked. I loved the giddiness, the adrenalin, the gamble. And I was blessed, seeming to find love under every stone, round every corner. I drank in the sheer delight of fellow human beings. But then I won the double. I found myself in love with two people. I've heard many argue that this is not possible, but I know it is. Giddiness turned to anxiety, adrenalin to pain. I'd lost the gamble.

Tristan & Yseult began its journey nearly two years ago. As Cornwall's oldest and greatest story it was asking to be told; Kneehigh, the obvious answer. But I was not sure. I didn't want to make a show about romantic love, about the chosen ones – leave that to Hollywood. How could I take a story we all know so well and make it sing, chime with my own life? But I didn't really know this story. As I began work, I realised that this ancient myth spoke straight to the dark heart of my own twenty-first century experience. This was not for Hollywood and happily ever after, this was for grown-ups: for those of us who know that love is a trap as well as a liberator; that the pain of choosing one person over another tears the soul and never quite heals.

Simply, I love this production. It is one of those rare shows that became greater than the sum of its parts. It took on a life, a universality that touched and surprised me each time we performed. As the story unfolded, I realized there was not one person in the audience who didn't profoundly recognise something in the situation – to love someone that you shouldn't, to betray someone you love, to be betrayed, to be left and, most painful, to be unloved. Suddenly this was not an epic tale of grand romantic love held at arm's length from our own experience, but a tender unravelling of love in all its beautiful and painful forms. The chorus took us through the piece, a band of 'love spotters': the unloved.

These are the people who look in on life, who are not chosen to play the starring role – these are at the heart of this production, because if we have all known love, we have also known the opposite.

And so, *Tristan & Yseult* is my letter to love. It speaks of longing and giving, abandon and obsession, loss and despair. It intoxicates as I have been intoxicated, and hurts as I have hurt. It tells how there is always a price, always a loser and always hope. It thanks love, it hates love and it celebrates love.

When first devising the piece, I began by literally casting the writers. I asked Carl, with his technical and verbal genius, to write for the court: King Mark and Frocin. I asked him to write in iambic pentameter as a reference to the great epic courts in literature. Anna I asked to look at the heart-broken – Brangian, Tristan and Yseult – with her direct and emotional voice lending itself to the tender poetry of the desperate. As the piece emerged, we began to place the text alongside the action and music, working into the themes and characters. But as with all good devising processes the magic lies where the boundaries blur, where technician becomes lover and poet becomes aggressor.

We are left with a script rich in detail, simple in its telling and true to the heart of the ancient myth.

Emma Rice – Director

Dedicated to Don and Barney Hill

Characters

LOVE SPOTTERS

WHITEHANDS

TRISTAN

KING MARK

FROCIN

MURDERER

MORHOLT

YSEULT

BRANGIAN

Tristan & Yseult was originally co-commissioned with Kneehigh by Nottinghamshire County Council STAGES, and was first presented at Restormel Castle, Lostwithiel, Cornwall, in July 2003 with the following company:

TRISTAN, Tristan Sturrock
YSEULT, Éva Magyar
KING MARK, Mike Shepherd
FROCIN, Giles King
MORHOLT / BRANGIAN, Craig Johnson
WHITEHANDS, Emma Rice
CHORUS & ANIMATION, Dean Wills & Steve Fergus

Adapted & Directed by Emma Rice
Designed by Bill Mitchell
Writers, Carl Grose & Anna Maria Murphy
Composition & Musical Direction, Stu Barker
Production Management & Lighting Design, Alex Wardle
Sound, Lucy Gaskell
Stage Manager, Karl Lappell
Costumes, Fiona Hankey
Rigger, Pete Hill
Props, set and construction, Dave Mynne, John Voogd & Graham Jobbins

Act One

Pre-show: LOVE SPOTTERS look for love. They take notes and search with binoculars.

They give out Lovehearts.

As Wagner's Prelude to Tristan und Isolde *plays, they each step up onto the stage.*

Scene 1

LOVE SPOTTERS:
We are the unloved.
We are the Love Spotters
Passion watchers
Kiss clockers
Love is at arm's length.

WHITEHANDS joins them. She is their leader.

WHITEHANDS:
Welcome to the Club of the Unloved.

A dart is fired into her heart.

It's no secret that we dream of our membership expiring.
But until that time, we stand on the sidelines
And tell our love story.
One of blood and fire
For what is love without these things?
So, I welcome you to our story:
We're all in it…all of us.

We see TRISTAN, who lies dying.

WHITEHANDS is with him, she looks out to sea.

TRISTAN:
Noir ou blanc? Noir ou blanc?

WHITEHANDS:
Do you love me?

TRISTAN:
Noir ou blanc?

WHITEHANDS:
He need not fear entry to our club, for he has been loved enough to save a thousand loveless souls. But this is the end: and you cannot have an end without a beginning.

Scene 2

We are taken into the court of KING MARK.

FROCIN captures a MURDERER, beats him and ties him to the mast.

KING MARK enters.

WHITEHANDS:
This is the Cornish King, Mark.
He imagines his kingdom vast and glorious
And in his soul, it is.

These days, the only thing he is close to
Is his own skin
He does not melt easily
He wears his armour hard
For kings may not show flesh
For fear of wounds…

KING MARK:
At birth, I'm told, Fate bestowed me three things:
The first being that I was born to be King,
The second was a heart that keeps good pace,
And the third, the gift of a friendly face.

KING MARK takes his sunglasses off and looks at the audience.

Two out of three ain't bad.

Now picture this country etched on a map.

FROCIN produces a map.

Then regard what you see as nothing but crap.
Forget what you've been taught or think you know:
The centre of everything's here – Kernow.
We don't look inland, there's not much point
Let Rome rule the Anglos, their foreheads anoint.
No, outward lies the way!
Inland there's little to write home about and much less to
say.

To my left, our sister nation, Brittany
A place quite akin to this vicinity.
But to my right howls Ireland, hell-bent on war
And this is a threat I cannot ignore.

To the MURDERER.

The best kings rule not with their hearts, but their
brains –
You'll learn this is one of my favourite refrains.

Explosion offstage.

But right now my heart hammers hard, it rarely takes
rest,
It is a war drum that thunders deep in my chest.

Look at this land that you have attacked,
Do you not find the odds are unfairly stacked?
So Morholt wants war. I'll not rise to his bait
I'm too clever to succumb to fire and hate.

You Irish dogs, you killers, this is your crime
If you burn my people you burn what's mine!
I'll defend my home with my dying breath
I can't do mercy – your punishment's death.

This is a calculated decision
One made with thought and kingly precision
It's no heart-strong whim or passionate gloat
This one's from the head – now slit his throat!

FROCIN gleefully slaughters the MURDERER and hangs him by the feet.

In these raging times, fear is the currency
War spills like wine and leaders lie – but not me.
I may not have a friendly face
But I'll not cheat to win the race.

My soul is in the rock, my blood in the rivers
This land a gift that the ocean delivers
We are fashioned by the wind and the sea
I'll not give up its freedom easily.

I bid you welcome to my court and to a war I have not chosen.

FROCIN:
I love you, King Mark.

Scene 3

TRISTAN arrives at the Court.

TRISTAN:
J'arrive!
Je veux suivre le Roi!
Je veux lui parler!

FROCIN does not understand, panics and tries to stop him.

TRISTAN enters the Court.

WHITEHANDS:
I often watch for what the tides bring.
Sometimes news, often wreckage.
But look what Fate's washed up,

Look what the wind's blown in:
Tristan – Prince of Hearts.
King of oceans.

KING MARK and TRISTAN seem to mirror each other.

KING MARK:

I don't know who you are, but I recognise you.
When I look at you, I see myself.

TRISTAN:

Je sais.

KING MARK:

Who are you?

TRISTAN:

Je m'appelle Tristan.
Je suis né en tristesse, par pitié,
Contre tout conseil ma mère a suivi son coeur.

Tristan. My name is Tristan.
I was born in sorrow, for pity's sake
Against all advice, my mother followed her heart
And had it broken by a king,
So now I follow mine,
Never staying long enough
To let the dust settle or roots grow,
So, I let the wind blow me,
I let the tides take me
I follow paths that others will not take
I was born in sorrow, for pity's sake
And this is where the storms have led me.

KING MARK touches TRISTAN's face.

Scene 4

MORHOLT, the Irish King, enters through the audience, with henchmen.

He makes himself at home.

MORHOLT:

How are you doing, ladies and gentlemen!
Morholt's the name,
We've got the whole place surrounded. Just stay in your seats and nobody will be harmed.

Yes it's lovely to be here in Kernow tonight – or as I prefer to call it,
That little piece of shite off the coast of Ireland!
The game is up, Mark: I'm here now.
I will have all your men, all your women
All your fish, all your tin
And all of your clotted cream.

I shall have all your wine, all your mead
And all your milk of human kindness.
I shall use your spires as toothpicks,
I shall use your lakes as mouthwash

I shall scorch your moors black,
Rape your seas,
And I shall pluck the flower of your youth.

Well Mark?
Got anything to say to your former people?
The King has nothing to say – as usual!

Oh and look who we have here, ladies and gentlemen:
It's little Frokkin! How are you, you wee bog man?

FROCIN:

My name's not Frokkin, it's Frocin.

MORHOLT:
 And what have we here – a face I have not seen before, a
 new boy in the court. Shall we have a word with him,
 ladies and gentlemen? Shall we? Got anything to say,
 new boy?

TRISTAN:
 Je parle seulement avec le Roi.

MORHOLT:
 He's French!
 If there's anyone I hate more than the Cornish, it's the
 French. Come along now, Mark, you know the score –
 lay down your weapons before Uncle Morholt.

 KING MARK lays down his knife at MORHOLT's feet

WHITEHANDS:
 Morholt takes what he wants
 Playing with the smaller nations like glass toys:
 To be broken.

MORHOLT:
 Come along, Frokkin.

 FROCIN lays down his knife at MORHOLT's feet.

 Run along, little doggie!
 Come along, new boy – you've seen what the big boys
 do. Now it's your turn!

 *TRISTAN goes to lay his knife down beside the others', but
 instead picks up the two knives and challenges MORHOLT.*

WHITEHANDS:
 Was this the moment when it all went wrong, or when it
 all went right?

MORHOLT:
 Now don't be stupid, boy!

FROCIN:
I wouldn't do that if I were you.

TRISTAN:
You're not me.

There is a vicious battle.

TRISTAN fights with MORHOLT, drives his knife into MORHOLT's eye and breaks the knife off, leaving the tip of the blade in MORHOLT's eye.

MORHOLT is dying.

TRISTAN has been stabbed in his side and is seriously wounded.

We flash forward in time.

TRISTAN:
Noir ou blanc?

WHITEHANDS:
Do you love me?

TRISTAN:
Noir ou blanc?

Back to the present.

KING MARK:
An eye for an eye!
Stripped! Stabbed! Coiled in pain!
For every life you stole, every village you burned, every unjust step you took on this soil: I will claim it back!

Do you hear me, Morholt?

KING MARK pulls a locket from MORHOLT's neck and opens it.

What's this? A single strand of red-gold hair...
Someone dear to you?

MORHOLT:

> Yseult!

KING MARK:

> Yseult! – I will have her! I will make her mine!
> Hell is close, Morholt, when all you can see is blood and darkness.
> Can you hear me? Can the dead hear?
> May you hang like a fog, twisting – listening to the sound of Cornwall and Ireland in complete, sweet union.
>
> Burn him! And send his ashes home.

KING MARK turns to the injured TRISTAN.

> They say blood is thicker than water,
> Well, mine is as rough as the oceans.
> I've never steered a safe course
> And nor have you…
>
> I need you to live.
> I don't know who you are but I recognise you:
> When I look at you I see myself.
>
> I need you to be my eyes, my right hand, to be me, my wanderer, my blood.

They embrace.

WHITEHANDS:

> Brotherly love is all very well,
> But too much of it is a ticket to hell.
>
> What would be best would be to send Tristan off on a quest.
> Mark my words, Mark, you know it's true:
> Send him off to pastures new.

KING MARK:

> Tristan, stand. Bring back my prize. This head of flaming red, darling of the blood-hungry Morholt.

TRISTAN:

Je vais trouver la femme.

TRISTAN builds his boat and sails away.

WHITEHANDS:

Stories are strange and stubborn things. They career unstoppably towards their Fate.

Of course he needs to find the woman who owns the single strand of red-gold hair that glints in the merest bit of light... I hate its colour already.

And so, blinded by love, pain and duty, our hero sets sail for...for – well, somewhere.

He's cast himself to Fate: no compass, no chart, no oars. Every heave of the boat and creak of its timbers adds salt to his wounds...salt to his wounds...

LOVE SPOTTERS:

Salt to his wounds... Salt to his wounds...

TRISTAN lands in Ireland.

Scene 5

YSEULT appears.

YSEULT: (*Sings.*)

Szivárvány havasán
Felnött rozmaringszál
Nem szereti helyét
El akar költözni
Ki kell onnan venni
Új helybe kell tenni.

YSEULT sees TRISTAN and climbs into the boat with him.

YSEULT:

Most, a sorsom
Itt a kezemben...

My fate is in my hands, literally:
I learned to heal – so saintly

But with healing comes touch
I may touch without permission
I may feel skin, the heat of pain
The glow of gratitude

And I am a very good healer
I have made it my business to be the best
The deeper the wound, the longer I may touch
So good, so angelic.

But gratitude can inspire love
And so I live in hope.

My fate is in my hands.

YSEULT places her hands on TRISTAN's wound. The pain wakes him. She speaks to him in her own language, calming him.

YSEULT:
Minden rendben… Én tudok gyógyítani…
Meggyógyítalak… Mindjárt jobb lesz… Így… Még egy
kicsit… Jól van… Jó… Úgy… Minden rendben lesz.
Brangian! Brangian!

BRANGIAN, her maid, enters.

BRANGIAN:
Yes, mistress?

YSEULT:
Get me some water.

BRANGIAN gazes at TRISTAN.

Water!

BRANGIAN returns with water. She washes TRISTAN's feet.

YSEULT:

> Like you, I was washed in by the tides to these strange shores
> Like you, I ran aground but was found.
> A man pulled me from the waves. He raised me, loved me like a sister but now he is gone.
> All I can do is care for you the way he cared for me.

YSEULT washes his face and bandages his wound.

WHITEHANDS:

> Beware, Tristan! – a man is vulnerable in a bath
> As they scrub your back and soap and sud you like mother did, your guard is down.

YSEULT teaches TRISTAN to walk again. They are playful together.

BRANGIAN brings TRISTAN's clothes.

BRANGIAN:

> Here are your things.

TRISTAN:

> Merci – mademoiselle…?

BRANGIAN:

> Brangian.

TRISTAN:

> Brang…?

BRANGIAN:

> Brangian.

TRISTAN:

> Brangian. Vous etes très gentille.

BRANGIAN giggles and runs off.

TRISTAN puts his clothes on.

The knife that he stabbed MORHOLT with falls out of his clothes.

YSEULT picks it up.

She pulls out the broken knife-tip from a chain around her neck and matches it with TRISTAN's broken knife.

WHITEHANDS:
The truth is out – like the baby with the bathwater.

YSEULT launches herself at TRISTAN, trying to kill him.

YSEULT:
Megöllek... Nem mész sehová... Kinyírlak... Te!

TRISTAN:
Qui? Qu'est que tu fais!
Je ne comprend pas? Pourquoi tu fais mal?

They fight.

BRANGIAN tries to intervene: TRISTAN knocks her flat.

TRISTAN:
Oh pardon!

They stop fighting.

They argue in their own languages, not understanding each other.

TRISTAN:
Qu'est-ce qui se passe?
Vous m'avez soigné la blessure, c'était génial –
Maintenant vous êtes complètement folle!

YSEULT:
Mit csináltál... Milyen ember vagy te... Hogy lehet ilyet... Egy asszony leütni?!

TRISTAN:

Je ne comprends rien!
English! Do you speak English?

YSEULT:

Of course I speak English!

These hands that can heal
Can also seal your fate.
Hate, as well as love,
Can bring colour to my cheeks.

YSEULT holds the dagger.

This sword can part flesh like a lover's tongue
And my soft hands tremble with it.
Hate as well as love can make my heart beat.
You killed my brother!

TRISTAN:

Your brother? I don't know your brother!

YSEULT:

You killed my brother, Morholt.
I pulled the end of your blade from his ashes!

TRISTAN:

Morholt was your brother?

WHITEHANDS:

Oh Tristan, you should have seen that one coming.
However bad that Morholt was, he dangled her on his knee.
A man in a bath is all at sea.

We go back in time.

We see MORHOLT and YSEULT together: she hangs a chain with a heart-shaped locket around his neck.

YSEULT:

Take care.

MORHOLT:

I will.

MORHOLT leaves.

Back to the story.

YSEULT:

I pledge my hate to you.

KING MARK appears far away. He holds MORHOLT's locket.

KING MARK:

Upon seeing a single strand of red-gold hair
I may demand to marry the woman who owns it.
This I do.

KING MARK throws the locket to TRISTAN.

TRISTAN holds out the locket to YSEULT.

TRISTAN:

Yseult – you must be Yseult.

YSEULT:

That doesn't belong to you!

TRISTAN:

No – it belongs to King Mark. And so, I'm afraid, do
you.

YSEULT:

Very well. I cast myself to the tides once again. This land
holds nothing for me now. You saw to that. Fate is out of
my hands.

Scene 6

The boat is built around them – the red sail is hoisted.

BRANGIAN:

Come on, boys! Hoist the main sail!

YSEULT:

If I'm to marry a king I've never seen
I will need a potion to help love along.
He might be as bald as a potato
His eyes may be small and cold
I might shiver when he holds me
I will need a potion to help love along.
Brangian!

BRANGIAN appears.

BRANGIAN:

Yes, mistress?

YSEULT:

I will need a potion to help love along –

TRISTAN:

And some sweet wine!

YSEULT:

To wash it down,
To take away the taste of hate, of Fate
Of marriage in such haste.

BRANGIAN brings two identical bottles of clear liquid.

BRANGIAN:

Right: here's some wine, and that's the potion.
Potion, wine – wine, potion. Have you got that?
Whatever you do, don't get them mixed up.

WHITEHANDS:

Love potions, there are many.
Sweet wines that promise love, where love is not.

The scent of money, the promise of a throne
To lie in a king's bed,
Well, not exactly love potions, but the thought of them
Can sweeten a sour kiss,
Smooth a rough hand, firm a soft belly;
And that old seducer, power
Hurried love in corridors
Unsuitable words to make a nation gasp.

But in my experience, a love potion is just an excuse for
wild abandonment with one you already love.

*TRISTAN and YSEULT play with the bottles and with the
idea.*

They drink the potion and the wine.

The Dance of Intoxication.

*TRISTAN and YSEULT swing on the ropes, kiss and finally
collapse together, asleep.*

Scene 7

BRANGIAN:
Land ahoy! I can see Cornwall!
Wake up! You've got to get dressed!
There's going to be a wedding! You've got to get married
to King Mark! I'll get the dress.
Hello Cornwall!
Oh look, there's King Mark! Hello King Mark!

BRANGIAN pulls TRISTAN off YSEULT.

Oh come on, you've been at it for weeks – can't you just
leave her alone?
Wave to King Mark…

BRANGIAN manipulates TRISTAN's arm into a wave.

Bonjour, King Mark!

Oh wake up mistress! – smelling salts…I need smelling salts.

BRANGIAN undresses YSEULT and gets her into a white dress.

Look, King Mark, she's beautiful! Look! Look at her!

BRANGIAN has turned away. TRISTAN and YSEULT embrace.

Don't look, King Mark!
Oh just pull yourselves together!
That's it Tristan, you take her clothes off…
Stop taking her clothes off!
Oh, the veil… preserve an air of mystery.
And the wedding bouquet!

The boat docks.

TRISTAN, BRANGIAN and YSEULT stand ready to greet KING MARK.

KING MARK steps aboard.

KING MARK:
I have weathered storms of dark premonition, made my bed unruly with worry. But here you are, safe – and with cargo.

TRISTAN:
C'est ça – j'ai cherché partout dans le monde
Et j'ai trouvé la femme.

I have found her. Yseult. Morholt's foundling sister.

KING MARK lifts her veil and their eyes meet.

KING MARK:
I had planned not to meet your gaze.
You were to be my reluctant guest, my unwilling bride
But now you are here, I am compelled to love you…

As the life leaked from your bleeding brother
I raged and made a vow that I would take what is his, as
he had taken what was mine.
Just vengeful words.
But now, you are here… arrived at these shores
You, Yseult, are more than I bargained for.

KING MARK kneels.

Can you forgive me?
Can you learn to love me too?
Will you be mine in life?
My companion? My anchor?
My queen? My wife?

Being King, I will never know who truly loves me.
Welcome. I bid you welcome to my court.

KING MARK leads YSEULT off the boat.

TRISTAN:

I was born in sorrow for pity's sake.
Against all advice,
I follow my heart

TRISTAN exits.

Scene 8

FROCIN:

Cut!… Cut the freaky harp music!
Now then: King Mark is in the chapel right now, getting
married…

LOVE SPOTTER:

Weren't you invited?

FROCIN:

What?

LOVE SPOTTER:

Weren't you invited?

FROCIN:

No!

FROCIN beckons LOVE SPOTTER close and kicks him.

But I haven't got a problem with that.

Mambo wedding preparation: bar, glasses, balloons to audience.

LOVE SPOTTERS dance.

FROCIN:

Now when King Mark comes, waggle your balloons in the air…
And don't muck it up!
Here he comes!

KING MARK and YSEULT enter with TRISTAN and BRANGIAN.

FROCIN pops the champagne open.

I love you, King Mark.

TRISTAN:

Ladies and Gentlemen: I give you the groom.

TRISTAN passes a microphone to KING MARK.

KING MARK:

There once was a time I boldly proclaimed
The best kings rule not with their hearts but with their brains
It was my mantra, my guide, my constant refrain:
But now my heart rules me – and I am changed.

You have turned me around from king to man
And I give thanks, and drink to fate's great plan.
I was alone, locked in, inside out –

But you, my bride Yseult, have killed all doubt.
So praise be to one and all in this court!
Enough of me, this speech was meant to be short –
Upon my love-loose tongue I shall place a ban,
And pass you guests over to my best man…

Both TRISTAN and FROCIN step forward to take the microphone.

…who is Tristan.

FROCIN is dismayed.

TRISTAN:
Mon Dieu!
I've seen some things… it takes a lot to rend my heart.
I've seen sons torn from fathers,
Daughters from mothers.
I've seen men with blood in their eyes take pleasure where they should not, and I did not flinch.
I've seen cities burn and I did not cry.
But to watch her hand take his, to hear the promise 'With my body I do thee worship' – is more than I can bear.
No wonder my wounds will not heal.

FROCIN takes the microphone from TRISTAN.

FROCIN:
Well that was nice…
I propose a toast: to King Mark and Queen Yseult!

FROCIN gets cross with the audience for not responding enthusiastically enough.

No, no, no: all of you!
Let's try again: King Mark and Queen Yseult!

FROCIN gets cross with the audience for joining in at the same time as him..

No! Don't mess it up! We'll try it again!

And if you don't get it right, we'll just all have to stay behind, won't we, until we do get it right.
Let's try again: King Mark and Queen Yseult! Hip! Hip! Hooray! Hip! Hip! Hooray!

KING MARK:

Thank you, Frocin: Let's celebrate!

The guests mingle.

YSEULT takes the microphone and confides in the audience.

YSEULT:

My head says: I have made my bed and I must lie in it.
With the King.
And I do love him:
He is my sense, my measure,
My morning, my safe harbour and my steady beat.
With this man I've met my equal.
Can I truly love two people?

FROCIN:

Ladies and Gentlemen: take your partners for the first dance of the evening!

They dance.

WHITEHANDS:

It's hard to keep things white:
Dirt loves it, blood loves it, sin loves it.
Christening gown, wedding dress, shroud:
All white.
If one were baptised in black,
It would not show up the dirt picked up along the way.

The dance ends.

Take a break!

Interval.

Act Two

Scene 9

LOVE SPOTTERS mingle in the audience.

As Wagner's Prelude to Tristan und Isolde *plays, they each step up onto the stage.*

LOVE SPOTTERS:
We are still the unloved
We are still love-spotting
Passion watching
Kiss clocking
Love is still at arm's length.

WHITEHANDS enters.

WHITEHANDS:
Welcome back to the Club of the Unloved.

A dart is fired into her heart.

We're fully paid-up members here
But there's another club
One we long to gain admittance to:
The Club Beloved…

But we'd never get in
It's an elite, classy establishment
The bouncers would smell our desperation a mile off!
Spy the nervous twitches and dark, sweaty patches
See through our faked confidence and forced smiles
And on refusing entry, they'd hear the dry empty rattle
of the hearts in our chests
Of course, we'd protest, say we were good friends with
the manager
They'd stare blankly ahead, and say over the din:
If you're not on the list, you're not coming in.

But don't pity us! Don't look at us that way, we can love
with the best of them.
We'll strike hard and ring the bell on the barometer of
love.

A couple of rounds of this, and they'll be begging us to
join their rotten love club!

See if they don't!

*They all try and fail on the 'barometer of love', hitting marks
such as 'Wet Halibut', 'Weak Bladder', 'Don't Bother', 'Pot
Noodle', 'Clinically Dead'.*

I told you: the love of the loveless is a desperate thing.
It's love or damnation and the quest is no joke,
That's why we pray our membership at Club Unloved be
revoked.

YSEULT enters and tries.

*The LOVE SPOTTERS ignore WHITEHANDS and turn
their attention to her.*

She hits the jackpot – 'Love Goddess!'

Scene 10

YSEULT:
Piros vagy fehér?
Red or white, red or white…

Where have I drifted now? I have married a King who
will expect certain things to be intact on the wedding
night.
I am no maid – and he will know this soon enough. He
will suspect…
Brangian… Brangian! Brangian!

Enter BRANGIAN.

BRANGIAN:

Yes mistress?

YSEULT:

Are you a virgin?

BRANGIAN giggles.

BRANGIAN:

I can't answer questions like that!

YSEULT:

Take my place.

BRANGIAN:

But mistress, I can't –

YSEULT:

Pretend to be me.

BRANGIAN:

No, I couldn't possibly –

YSEULT:

Or we are both lost!
It is not my husband who makes my heart pound,
My senses fly, my soul touch the sky.
It is the other:
My night, my moon, my wild cry.

YSEULT makes up BRANGIAN: makeup, perfume, dress.

BRANGIAN:

This morning I prepared the bridal bed.
How fresh the sheets smelt,
The pillows were plump with anticipation,
Like me.

We've covered every angle, the mistress and me.
I am to smother myself in her sweet perfume
And let down my hair – although the colour does not
compare.

47

But he will not notice:
The lights will be dimmed and the King will be blinded
with love.

We have the same nightgown: loose and easily lifted.
And when the deed is done, the King will be satiated
with sleep
And I shall slip out from beneath him and she shall slip
in.
Easy!

I have asked the cook for advice, pretending I am soon
to be wed.
She said I must grit my teeth and pant with pleasure,
even if it not be there.
I'm used to pretending so that shouldn't be a problem.
But what if I do enjoy it? What then?
The cook just raised her eyebrows and gave me a cloth
for the blood.
Blood? What blood?

BRANGIAN turns to the LOVE SPOTTERS for advice but
they haven't a clue.

LOVE SPOTTERS:
Not really sure. You look lovely though.
Good luck!

WHITEHANDS: (*'Wild Nights' by Emily Dickinson*)
Wild nights,
Wild nights
Were I with thee,
Wild nights should be our luxury

Futile the winds to a heart in port,
Done with the compass
Done with the chart
Rowing in Eden, ah the sea
Might I but moor tonight in thee.

KING MARK approaches BRANGIAN blindfolded and makes love to her.

TRISTAN makes love to YSEULT.

YSEULT swaps with BRANGIAN – the plan has worked.

BRANGIAN collects the sheets to wash.

BRANGIAN:
> I shook like a leaf.
> He whispered, 'Be calm, sweet one' –
> But of course I could not speak.
>
> He inhaled the scent of my flesh
> As if he wanted to remember it.
> And then… and then I felt the weight of him,
> Oh Lord!
> My knees quaked, my hands trembled,
> My stomach turned somersaults.
>
> And – servant though I am – I did not want to leave,
> To slip out from under him and be replaced:
> Bugger duty!
>
> This morning, with rings under my eyes
> I took the wedding breakfast in
> And removed the sheets with my own blood on them.
>
> What of my wedding night?
> Will a queen take my place for me?
> Not likely. Not bloody likely.
> But last night it was me who was the beloved.

KING MARK enters brushing his teeth.

BRANGIAN is waiting for him to notice her.

KING MARK:
> That will be all. Dismissed.

BRANGIAN exits and joins the Unloved.

YSEULT joins KING MARK in the bathroom. They seem happy, relaxed.

KING MARK exits and passes TRISTAN on the way out.

KING MARK:

Good morning.

TRISTAN joins YSEULT in the bathroom. He whispers in her ear – it is his wedding speech, in French.

YSEULT rushes out.

TRISTAN looks in the mirror.

FROCIN is suspicious. He takes a photo of TRISTAN.

Scene 11

FROCIN:

Spit and venom, bile and hate!
I know you shagged her – you're dead meat, mate!
But glorious King Mark would not believe a poisoned
rant from ugly old me,
Unless I find the evidence… what I need is some hard
proof.
Christ, good King Mark'll hit the roof!

I'll capture sweet nothings recorded on tape
As you slither and slide like a couple of snakes!
Hell, all I need is one decent photo
Of Tristan and Yseult in flagrante delecto!

I could keep quiet, could hold my tongue –

But to dob you in, it's half the fun!

FROCIN gets a microphone and a camera.

The King will freak, he'll shit kittens,
He'll cut the lovers into ribbons,

Cut out their tongues, gouge out their eyes
Tear out their hearts and eat their insides.

Me? – I'll be thanked, praised and adored.
King Mark, I want no gold – love's my reward.

KING MARK appears in FROCIN's imagination.

KING MARK:
Frocin, you're the only thing that brings me joy –
The only thing that brings me joy.

FROCIN:
Oh thank you, your majesty...
Tristan! You're in my head both day and night,
But you'll get yours, you little shite!

TRISTAN and YSEULT meet secretly.

TRISTAN puts on YSEULT's dress; YSEULT puts on TRISTAN's suit and shades.

FROCIN spies on them.

YSEULT:
What is love?

TRISTAN:
It is a promise.

YSEULT:
And a lie.

TRISTAN:
It is the roar

YSEULT:
And the whisper

TRISTAN:
It is hope

YSEULT:
And despair

TRISTAN:
It is being found

YSEULT:
And getting lost

TRISTAN:
A wish

YSEULT:
A curse

TRISTAN:
Which is which?

YSEULT:
Which is worse?

TRISTAN:
What does love mean?

YSEULT:
It doesn't mean anything

TRISTAN:
It is everything

YSEULT:
A shadow

TRISTAN:
And a blinding light!

YSEULT:
The sensation of…

TRISTAN & YSEULT:
Senselessness

YSEULT:
　　We are tumbling

TRISTAN:
　　You'll fall forever

YSEULT:
　　Then we fall together

TRISTAN:
　　I feel…

TRISTAN & YSEULT:
　　Immortal

TRISTAN:
　　Right now.

YSEULT:
　　Right now.

TRISTAN:
　　Love me.

YSEULT:
　　Love me.

TRISTAN:
　　I do.

YSEULT:
　　I do.

　　TRISTAN and YSEULT embrace.

　　FROCIN moves in to get a closer picture.

　　He takes the photo and raises the alarm.

　　TRISTAN and YSEULT are taken captive.

Scene 12

KING MARK enters.

FROCIN:
King Mark! I did it for you.

KING MARK:
You have deceived me, lied and played me well.
Is it hot in here, or am I in Hell?

FROCIN:
King Mark, I –

KING MARK: (*To FROCIN.*)
What do you think you're doing? Helping me out?
That by showing me truth you've extinguished all doubt?
Frocin, you fool! Ignorance is bliss!
I was happy not knowing – but you bring me this!

(*To TRISTAN and YSEULT.*)

And you...

I admire your pluck and courage, my dears.
To seize this moment without care or fear
To dare to kiss whilst my back is turned
Your husband, your King, your everything spurned.

Forgive me – I'm shocked, knocked, in a daze:
I'm not familiar with being betrayed.
I fear revelation's aftermath:
Your knife in my heart ignites flame and wrath.
And this is a passion I cannot rule,
You've turned your King into a broken fool.

I have wasted myself on you both.
Wasted my words, wasted my time
Wasted my needs, wasted my wine

Wasted my love, wasted my breath:
Wasted your lives – I sentence you… death!

FROCIN goes to kill TRISTAN and YSEULT but KING MARK stops him.

Stop!
I ruled with my brain then ruled with my heart
But gone is the mantra I used to impart.
You have stripped me of it, my world is undone
So I shall rule without both – let ambivalence come.

Leave. I never want to see you again.

TRISTAN and YSEULT leave the court.

To FROCIN.

For your own good, do not come near me.
I've suffered you because of your loyalty
Like a dog you've lingered, like a king's best friend
But what you've done, no grovelling can mend

FROCIN tries to speak

You say you love me and yet you do this?
Get out of my sight. You shall not be missed.
You've killed the only thing that brought me joy
The only thing that brought me joy…

FROCIN joins the Unloved.

Scene 13

WHITEHANDS:
Love haunts the forest.
The dust has settled, and so has love.
It is familiar, slow like mornings; sleepy like dusk.
The dust has settled and so has love.
Time slips by.

TRISTAN plays and sings for YSEULT.

WHITEHANDS, TRISTAN, LOVE SPOTTERS:
> Oh sink down upon us,
> Night of love make me forget I live.
> Oh take me into your arms,
> Free me from the world.
>
> The sun lies hidden in our breast,
> Stars of bliss shine bright.
> Heart to heart, lip to lip:
> Bound together in one breath.

YSEULT dances for TRISTAN.

They sleep.

WHITEHANDS:
> I can only dream of such passion.
> It was hard to tell who was who.
>
> Tristan and Yseult
> Yseult and Tristan
> Trisuelt.
> Love is blind to blemishes:
> A red skin is rose coloured,
> Dull hair a river to swim in:
> And Christ, did they swim!

WHITEHANDS exits. Birdsong.

KING MARK enters, birdwatching.

He finds TRISTAN and YSEULT.

KING MARK:
> I thought the woods empty, yet here lie two beasts
> entwined.
> Lucky you, blissful sleep
> Lucky you, no cause to weep.
> Is there nowhere here on earth I can go
> Where I can escape the sight of you? – No.

KING MARK pulls out his knife and goes to kill them.

My mind says murder, tempts me to kill;
My heart speaks different – I love you both, I love you
still.

*KING MARK pushes his knife into the ground between the
lovers, then exits.*

*The LOVE SPOTTERS wake TRISTAN and YSEULT and
mime to them what has happened.*

WHITEHANDS:
Look! It's worn off! Like all love potions do.
Like all first love does. Like false silver from a knife,
Like the haze of sweet wine.
The eyes that saw no other notice the world.
And the harm that love can do,
The harm that love can do.

To TRISTAN and YSEULT.

You have spent your passion but love is left.
The world you left behind when blind with each other –
Husband, King, Father – still remains.
Perhaps it is time to return.

TRISTAN crowns YSEULT with leaves.

TRISTAN:
If ever you need me, I will be there.

YSEULT:
If ever you send for me, I will come.

TRISTAN leaves.

Scene 14

KING MARK approaches YSEULT. She gives him back his knife.

They sense each other's pain. They return to each other.

They are bruised, sad and warm.

WHITEHANDS watches them leave…

Scene 15

Time passes. We find ourselves in the present day.

TRISTAN lies dying.

TRISTAN:
Noir ou blanc? Noir ou blanc?

WHITEHANDS:
So, we have come full circle, time has passed and we find
ourselves back at the end.
Who am I?
I am Tristan's wife – by virtue of my name.
Yseult.

They call me Whitehands but my name is Yseult.
Yes, it is a coincidence. There aren't many of us about.
He tracked me down, found me and married me. Because
he thought the name would remind him.

Me? I have loved him wholly since the first moment I
set eyes on him. But he cannot see me.
It's always been this way with him.
He walked on air, his eyes distant
And no matter how I bathe his wounds
Or what feasts I prepare, I cannot make him see me…

I am half a wife.
I warm his bed, but not his body.
I serve his wine, but he is not mine.

I am liked for my goodness
But I say to hell with goodness!

Sometimes he calls my name,
But it is not me he wants.
He reaches in the dark
But when he sees it is not her, he turns.
And as he turns, I burn. I burn.

Why can't he see me?
Why can't he forget?
Why can't he heal?

TRISTAN:

Yseult!

WHITEHANDS:

I once asked him: 'What is love?' –
He replied, 'It is the euphoria of impossibility.'
Well I feel no euphoria
And I cannot be good any longer.

TRISTAN's wound has reopened and he is bleeding to death.

The LOVE SPOTTERS tend to him.

Some wounds will not heal, and love's wounds are the
deepest.
Some wounds just will not heal.

TRISTAN:

Yseult! Yseult!

WHITEHANDS:

He has sent for her.

*The LOVE SPOTTERS beckon WHITEHANDS over to
TRISTAN.*

He knows death is close and wants to drink his last
breath with her.
Dreams of her healing touch and of love restored.

TRISTAN:

> Si c'est bien c'est blanc – si non, c'est noir.

WHITEHANDS:

> The ship will hoist a white sail if she is coming,
> a black sail if she is not.

TRISTAN:

> Noir ou blanc? Noir ou blanc?

WHITEHANDS:

> The loved attract love,
> If you are already loved, more love just seems to come
> your way.
> Whereas us – the unloved – must take Fate in our hands.
> So don't judge me.
> Those of you with pits in your stomachs,
> With rents in your hearts, will know.
>
> Bugger goodness!
> And damn the boats that do not carry love my way!

TRISTAN:

> Noir ou blanc? Noir ou blanc? Black or white?

WHITEHANDS:

> You want to know?
> You really want to know if your precious Yseult is
> coming?
>
> *White sails fill the space.*
>
> Black. The sail is black.
>
> *TRISTAN dies.*
>
> *YSEULT arrives, pushing WHITEHANDS out of the way.*
> *She sees TRISTAN dead, cries out in agony, and dies beside*
> *him.*
>
> *KING MARK appears.*

Where does all the wasted love go?

TRISTAN and YSEULT change into LOVE SPOTTERS.

It's hard to keep things white:
Dirt loves it, blood loves it, sin loves it.
If one where baptised in black,
It would not show the dirt picked up along the way.

WHITEHANDS joins the LOVE SPOTTERS.

They leave the stage together.

The end.

THE BACCHAE

A TRAGEDY IN ONE ACT

Foreword: *The Bacchae*

There's a reason why we still tell the stories that Euripides and his Greek playwriting pals wrote all those years ago. When this show was in rehearsal, you couldn't move for revivals of Greek Tragedies (and still can't). In working with Emma, Anna and the company on creating a new version of *The Bacchae*, I discovered what that reason was.

As ever, Emma approached the source material in her own personal and iconoclastic way. She wanted a tutu-clad, all-male chorus playing the women of Thebes, and big Music Hall sing-along numbers for the audience to join in with. She staunchly disregarded the classical conventions Euripides had set up – characters were expanded, journeys threaded through with greater complexity, and there was even the invention of a few new faces (enter Pamela, P.A. to King Pentheus). Gone was the archaic translation. In place, a combination of rap and poetry, haikus and Hungarian god-speak.

The challenge was to rewrite the story with a modern, entertaining and accessible voice whilst at the same time retaining the dramatic weight and meaning of each scene. Sounds easy? It wasn't. Why? Because Euripides is The Dude. He knew how to write some kick-ass drama. As Anna and I started to break open and crawl beneath the skin of his play, we began to see the enormity of the challenge we'd set ourselves.

I wasn't prepared for the psychological depths inherent in his characters or the resonance we discovered along the way. Images and ideas that Euripides had written into his play roughly two and a half thousand years ago were front-page news at the time we wrote this. Be it Guantanamo Bay's prisoner abuse or the Beslan School Massacre, we were forced to question belief and examine what lengths humanity went to to justify those beliefs through

unspeakable acts. The themes of the play were televised nightly… Everything seemed to swing back to the shadow of religious and political fundamentalism looming large in the Middle East and the American Right. And for me, this is what our version of *The Bacchae* was about.

Euripides understood humanity all too well and he did such a fine and fierce job that (scarily and sadly) the resonance of this play echoes clearly to this day. He wrote what was happening in his political and religious atmosphere at the time and created theatre that reflected that world. With his help, so did we.

Carl Grose – Writer

Dedicated to Wendy Greenhill

Characters

THE BACCHAE

AGAVE

CADMUS

TEIRESIAS

PAM

PENTHEUS

DIONYSUS

CORYPHAEUS

The Bacchae was first presented as a Kneehigh Theatre co-production with West Yorkshire Playhouse, Lyric Hammersmith, Bristol Old Vic and Hall for Cornwall, at the West Yorkshire Playhouse in September 2004 with the following company:

DIONYSUS, Róbert Lucskay
AGAVE, Éva Magyar
PENTHEUS, Giles King
CADMUS, Mike Shepherd
TEIRESIAS, Charlie Barnecut
PAM, Leonie Dodd
CORYPHAEUS, Craig Johnson
CHORUS, Dan Canham
MUSICAN/CHORUS, Andy Brodie
MUSICIAN, Sarah Moody

Directed & Adapted by Emma Rice
Designed by Bill Mitchell
Writers, Carl Grose & Anna Maria Murphy
Composer & Musical Director, Stu Barker
Lighting Designer, Malcolm Rippeth
Choreography, Éva Magyar & Emma Rice
Production Manager, Alex Wardle & Eddie De Pledge
Stage Manager, Jack Morrison
Technical Stage Manager, Dominic Bilkey
Assistant Stage Manager & Wardrode, Ami Mendes-Houlston
Film, Laura Hardman
Set, props & costumes built by West Yorkshire Playhouse

Scene 1

Party noise offstage.

Houselights dim. Party noise swells then settles.

THE BACCHAE break into the palace.

They see tutus hung above them; they lower them and put them on.

AGAVE enters. THE BACCHAE hide around the palace.

AGAVE looks out of the window. She dances gently.

CADMUS enters and joins her.

TEIRESIAS enters, looking for CADMUS.

TEIRESIAS:
Cadmus? Cadmus?

CADMUS:
Shhh!

AGAVE puts CADMUS back into his wheelchair, then exits.

Enter PAM bringing newspapers.

PAM:
Good morning sir! Good morning sir!

PAM fetches a glass of water and places it on the desk.

PENTHEUS enters, crosses to desk.

Good morning, your Majesty.

PENTHEUS:
Good morning, Pamela.

CADMUS:
Good morning, Pentheus.

PENTHEUS:

Grandfather.

PENTHEUS sits at his desk and looks at newspapers, gets more angry, reads about those who are leaving for the mountain.

Pamela, sort out that racket!

PAM goes to the window.

PAM:

Keep the noise down!
Stop this nonsense!
Go back to your homes!

PENTHEUS gets up and goes to the window.

PENTHEUS:

This behaviour will not be tolerated!

CADMUS, TEIRESIAS and PAM are watching.

What are you looking at?

AGAVE enters with a suitcase, she tries to leave.

Mother, what are you doing?
Why are you dressed like that?
Mother, I forbid you to leave!
Are you out of your mind?
That man is an impostor! A fraud!
Think about what you're doing!
What about your health? Your headaches! Mother!

AGAVE leaves.

A king must know his boundaries, without them he is lost.
He needs to know where one land ends and the other begins.
A king must know what's what.

He must decide what gods his people worship and expel all others.
Get out all of you!

PAM, CADMUS and TEIRESIAS all leave.

PENTHEUS moves back to his desk. Cello plays.

PENTHEUS exits.

Scene 2

THE BACCHAE enter. They play with the telephone, take newspapers from PENTHEUS' desk and make them into thyrsi.

DIONYSUS enters with loud music and dancing.

BACCHAE:
Praise Dionysus, Son of Zeus!

DIONYSUS:
Ajánlhatok valamit?
Egy kis bort mielött kezdünk?
Csak egy csöppet, csak az íze végett
Lassan vagy sietve ihatja.
Én, egy szakertö vagyok
Nem lesz rossz véleményem ha szürcsöl
Vagy ha az arca kipirul…

CORYPHAEUS:
They don't understand you –
You must speak in English, for we are in Leeds.

BACCHAE:
Leeds!

DIONYSUS:
Can I offer you anything?
A little wine before we begin?
Try a drop. Just a taste.

Sip it slow or drink with haste.
Me? I'm hardly a connoisseur
I won't judge you when you slur
Or when your cheeks flush pink
And you start to sink
Into a hazier place
Where hearts quicken pace
And inhibitions melt.

I'll be yours
And you'll be mine
So much can change
After a little wine.

For those of you who do not know us,
I am a God and this is my chorus.

BACCHAE:

Praise Dionysus! Son of Zeus!

DIONYSUS:

Let me introduce you to my greatest fans, my screaming devotees,
Worshippers I've collected from across the seas.
This is my cult, my entourage, my minions you see.
They know when to bow and glorify me!
It's great – they think I'm such a swell guy,
Go on. Tell them who you are.

BACCHAE:

We are The Bacchae!

SONG: 'We Are The Bacchae!'

We are The Bacchae
We are his women
So wild with desire

We are The Bacchae
We are his wives
And we burn in his fire

Wonderful and deadly
Only when he wants us to be
Beautiful and wickedly
We follow him to ecstasy!

CORYPHAEUS:
My name is Coryphaeus
I am your chorus leader
I am dressed up like the cat's dinner
And proud of it
I am the Queen of Sheba
I am tweaked up like a girl racer
And ready to go
I am lamb dressed as steak
And I am awake!

In other words
I am young, single and up for it!

Nothing ever happened in this town
But that's all changed now
Since he arrived
I didn't need to be persuaded
I didn't need to be lured
I've got a yearning
A burning
That needed to be cured!

GRANDMOTHER BACCHAE:
I am a grandmother
I'm sagging in every place there is to sag
My stomach is stretched beyond reason
And my breasts go their own way
Yes, I can knit, bake cakes, rock babies
And offer useless advice
But I'm sick of it!

I want to walk down the street with my pants around my
ankles

I want to shave off this stupid thin hair and paint my
head green!

I tell you, I've worshipped some Gods in my time
But this one is the best for grandmothers!

So bugger knitting! Sod cakes! And up the arse of
toothless food!

TEENAGE BACCHAE:
I am a Teenager
And I am bursting out all over!
I'm ready for the first kiss
For the taste of tongues
But I don't want an old duffer with his puffer
And dodgy tick tock ticker
Or a fumbling mumbling boy
With frantic fingers and volcanoes on his face
I want a man in his prime
Who says he'll be mine
Pain and pleasure at my leisure!

BACCHAE:
Pain and pleasure at our leisure!
PAIN AND PLEASURE AT OUR LEISURE!

CORYPHAEUS:
Praise Dionysus, Son of Zeus!

DIONYSUS:
Látom az arcotokon
Hogy nem ismeritek a görög isteneket
Figyelem! Hallgassatok ide!
Cory!

CORYPHAEUS:
Oh dear! – He can see by the looks on your faces
That you're unfamiliar with Greek deities
Pay attention! You have to listen!
There's some very complicated exposition.

Right. There are two worlds.
One is the world of the gods
Which is up high, up there
There live the top dogs
Powerful gods, got it?

The other world is the world of mortals. That's you lot.
And you're down here on ground level, low
Mere mortals, see?
Up: Gods. Down: Mortals.
Are you still with me? Gods! Mortals!
You've heard of Zeus, right?

THE BACCHAE play the roles of ZEUS, HERA and SEMELE.

ZEUS:
I am Zeus!
God of all Gods and tough as old boots!

CORYPHAEUS:
Now – Zeus was married to a fiery Goddess with a
jealous heart: Hera.

HERA:
I am the jealous Goddess Hera!

ZEUS:
I've seen her in action. I wouldn't go near her.

CORYPHAEUS:
They'd sit and watch the puny mortals play
Until, heaven help us, one fine day
Zeus cast his wandering eye over the city of Thebes
And saw a young woman who suited his needs.

SEMELE:
I am Semele, a mortal
I am daughter to Cadmus, King of Thebes

CORYPHAEUS:

 He was here earlier,
 The old guy in the wheel chair, remember?

SEMELE:

 I also have a sister, Agave…

CORYPHAEUS:

 Hang on, we haven't got to that bit yet:
 Who you need to focus on now
 Is the mortal, Semele –
 A lovely girl who's very pretty.

ZEUS:

 I want her! And I will have her!

 ZEUS descends and makes love to SEMELE.

CORYPHAEUS:

 They say the sky separates these worlds
 But keeping them apart is no mean feat
 And nothing but calamity can reign
 When these two worlds reach out and meet!

ZEUS:

 Not bad for a mortal.

SEMELE:

 He has sown his mighty seed inside of me!

CORYPHAEUS:

 From this holy union was conceived a babe.
 Half Zeus, half Semele – remember, Up: Gods! Down:
 Mortals!
 Now, Agave –

SEMELE:

 That's my sister…

CORYPHAEUS:

 She was here too – the woman in the blue suit.
 She didn't believe it when Semele said –

SEMELE:
I have been in Zeus's bed
And I carry his child, sister!

CORYPHAEUS: (*As AGAVE.*)
You carry no son of a God!

DIONYSUS:
Ha!

CORYPHAEUS: (*As AGAVE.*)
Sister, don't use Zeus as a ruse to protect your good
name!
If the boy's a bastard you've only yourself to blame.

DIONYSUS:
Shit-stirrer! Liar! I am a GOD!

BACCHAE:
Praise Dionysus!

SEMELE:
Zeus! How can I prove to the world
That I am pregnant with your child?

CORYPHAEUS:
What?

ZEUS:
What?

HERA:
WHAATT?!!

CORYPHAEUS:
And jealous Hera howled and loosed
A jagged bolt from the heavens.
Poor Semele was blasted to smithereens,
But in the smoldering remains
Of that black and bloodied stain
Lay the babe, uncooked by the Goddess's rage…

ZEUS:

> Ah, a beautiful baby! It is you!

DIONYSUS:

> And now, here I stand
> Thyrsus in hand
> By all appearances,
> A fully grown and handsome man.
>
> After so many years of wandering the wilderness
> I have arrived in Thebes, at the house of the unbelievers –
> The royal palace of Cadmus, Agave and the young King Pentheus.
>
> The trap is set, I have thrown the net
> And I almost have her – Agave – she's nearly mine.
> I have come to teach them that to worship me is divine
> That my mother Semele spoke the truth!
> That I am truly the God, Dionysus! Son of Zeus!

BACCHAE:

> Praise Dionysus, Son of Zeus!

SONG: 'We Are The Bacchae!'

> We are The Bacchae
> The trance, the blood
> The flaming fire
>
> We are The Bacchae
> The dance, the wine
> The shameless desire
>
> Dangerous and so sublime
> Follow us to his holy shrine
> Taste the blood and taste the wine
> Join with us and be divine!

Scene 3

The forest. AGAVE enters and finds DIONYSUS and THE BACCHAE.

DIONYSUS:
Agave. I knew you would come.
I've been waiting for you.

AGAVE:
I was wrong –
I need to… I want –

DIONYSUS:
Sshhhh…

AGAVE:
I have left my home –

DIONYSUS:
Ssssshhh……

AGAVE:
My son, he doesn't believe –

DIONYSUS:
Sssshhh…
This way.
Come this way, Agave.

AGAVE joins THE BACCHAE.

THE BACCHAE take her suitcase, jacket, sunglasses and headscarf.

DIONYSUS lifts her.

THE BACCHAE manipulate and transport AGAVE.

DIONYSUS and AGAVE exeunt.

THE BACCHAE dance and exeunt.

Scene 4

The palace. CADMUS enters, watches THE BACCHAE
partying outside and puts on a tutu. TEIRESIAS enters.

SONG: 'What Does It Matter?'

TEIRESIAS:
Cadmus? Cadmus!

CADMUS:
Here, Teiresias, my old, old friend.

TEIRESIAS:
Thank Heavens. I thought you'd gone off without me!

CADMUS:
Paranoia's a symptom of senility.

This is Teiresias, the once-great prophet
He's seen it all, but now his sight has faded like
weathered paint
And he is as blind as a rock

TEIRESIAS receives a vision, and is overcome.

CADMUS:
I am here, Teiresias.

TEIRESIAS:
Cadmus!

CADMUS:
What can you see my friend?

TEIRESIAS:
Are you crying?

CADMUS:
No. I am not crying.

TEIRESIAS:
No. I mean I've seen you crying.

CADMUS:

You must be mistaken.

TEIRESIAS:

Yes, yes. You are probably right. Mistaken.

CADMUS:

Fennel wand or ivy wreath? Now…which one should I take?
Or rather, the question is, which one should I leave behind?

TEIRESIAS:

We lose the ability to make up our minds.

This is Cadmus: devoted husband, father and founder of Thebes
He used to be a mighty king, a man who once had everything.

CADMUS:

Now, ivy wreath or fennel wand?

TEIRESIAS:

Take both or we'll be here all day!

CADMUS:

Why not? We go to worship my grandson after all.
No, not that annoying little shit, Pentheus!
The other one! My godly grandson – Dionysus!

TEIRESIAS:

Praise Dionysus!

His wild fever has gripped Thebes!

CADMUS:

Teiresias, I've never seen this city so alive!
For too long now the people have been deprived.
It is time to celebrate!
Let's dance, toss our old, grey heads

And shake our rusty, wrinkled cages!
We've not let our hair down in ages!

TEIRESIAS:

You've reminded me there's blood in these blue-cheese veins!

CADMUS:

A good knees-up will banish these aches and pains!

TEIRESIAS:

Forget creaking bones, and that our grey skin sags!

CADMUS:

Who cares if I wear a colostomy bag!
You're only as old as the age you feel!

TEIRESIAS:

So let's go to the mountain to feel and heal!
Before we're burned to ash and stored in a pot!

CADMUS:

Let's join in the fun! Why the bloody hell not?
We're dressed correctly, to join with The Bacchae!
So – wand or wreath? Uhh… Now where on earth was I?

TEIRESIAS:

You were going to take both.

CADMUS:

But is that permitted?

TEIRESIAS:

My dear old Cadmus, pay it no mind. Come. To the mountain!

CADMUS:

I'll lead. You're blind.

CORYPHAEUS writes the words to the song on the blackboard.

CORYPHAEUS:
Ladies and Gentlemen, we're going to get this party
started with a bang, and a good old-fashioned sing-along:
I sing a line, you sing it back to me.
Ready? 1 – 2 – 3 – 4!

CORYPHAEUS, CADMUS & TEIRESIAS: (*Singing.*)
What does it matter?
Why don't you let yourself go?
Pack up your bags, drop your pants!
Only then will you know! (*Repeat.*)

CADMUS gets into his wheelchair, they prepare to leave.

CADMUS:
Come on, let's all go to the mountains!

Music ends abruptly, enter PENTHEUS.

PENTHEUS:
What on earth is going on here?
I thought you two were supposed to be the city elders?
Grandfather, you used to be King!
Teiresias, the great, wise seer – what are you thinking?
Have you lost all your faculties?
Are you completely deranged?
Let me ask you a question: if someone told you to jump
off a cliff, would you?

CADMUS & TEIRESIAS:
No.

PENTHEUS:
Exactly!
So when some foreigner turns up, claiming to be your
dead daughter's son, the son of Zeus no less, and says
'I'm the new god in town, praise my name by drinking
wine and cavorting about half-dressed on a mountain all
day!' why is it that everyone starts getting down on their
knees and praying?

CADMUS & TEIRESIAS:
>Praise Dionysus!

PENTHEUS:
>Has everyone in this city fallen for this bogus god but
>me?
>Am I the only one left with some semblance of sanity?
>Well?
>What have you got to say for yourselves?

CADMUS:
>It's true. I was once King.
>Now you hold that title, Pentheus.
>But don't forget, I'm still your granddad
>And in my eyes, you're still that little uptight brat
>I used to put over my knee whenever he spoke out of
>turn

PENTHEUS:
>I'd like to see you try that now!

TEIRESIAS:
>So would I!

PENTHEUS:
>And don't think I don't know what you're up to,
>Teiresias!
>Hobbling up the mountain to inspect the sacrifices are
>we?
>Trying to cop a feel of naked, nubile young flesh more
>like!

CORYPHAEUS:
>Cop a feel of this then!

PENTHEUS:
>If it wasn't for your frailty and age, I would imprison
>you both without delay! So, as your King, I forbid you
>to go.

TEIRESIAS:
I knew he was going to say that!

CADMUS:
Finished? Taxi!

CORYPHAEUS brings wheelchair over

To the mountain my good woman – and step on it.

TEENAGE BACCHAE:
Oh dear, Pentheus, please show some respect
These old men comprehend while you merely pretend to know
Reverence starts with family – you still have a long way to go.

Scene 5

PENTHEUS:
Pam? Pamela?

PENTHEUS exits as PAM enters.

PAM:
Hi. Hallo. I'm Pamela
P.A. to King Pentheus
My purpose is to organise
I've little time for wildness!

I disapprove of dancing
And I certainly don't drink
I had a sherry one Christmas
And was sick in the sink.

I devote myself to service
I'd take a bullet for this man
Is that beyond the call of duty?
Well, just file it under 'Pam'

PENTHEUS enters.

PENTHEUS:

Pamela. How are you?

PAM:

How am I? Sir, I'm fine, thank you.

PENTHEUS:

Pamela. There is something I want to ask of you as a woman…

PAM:

As a woman sir?

PENTHEUS:

Yes. Pamela. I need you…

PAM:

Yes sir…

PENTHEUS:

I need you to go to the mountains.

PAM:

With you?

PENTHEUS:

No, not with me! What were you thinking? I need to know what's going on up there, what my grandfather is up to… my mother.

PAM:

Sir. Isn't it a bit wild on the mountains, sir?

PENTHEUS:

Pamela, I wouldn't send you anywhere dangerous, now would I?

PAM:

No of course not, sir, and I wouldn't mind going, really I wouldn't, but…couldn't one of your guards go, sir? Your diary is so full this week, sir, I really need to keep on top

of the typing, the reports…and the files are in a complete mess….

PENTHEUS:

Pamela! It needs to be a woman. A man would be
noticed, and you've always been good at blending in.
Part of the furniture.

PAM:

Yes sir, part of the furniture, thank you sir.

PENTHEUS:

Well off you pop, Pamela. Straight away.
And don't tell anybody what you see apart from me.

PAM exits.

TEENAGE BACCHAE:

Poor Pamela.
He hasn't guessed that under her never-been-touched
vest
Her heart pounds like a running river.

PENTHEUS looks at a newspaper.

PENTHEUS:

Mother, what has happened to make you do this?
What has happened to you?
This charlatan must be brought to heel.

He speaks on the telephone.

Hello, Zucchini? This is Proud Rabbit.
This so-called god is going to rue the day.
Dispatch a battalion! Bring me this foreigner right away!

*Enter THE BACCHAE with newspaper soldiers: PAPER
ARMY.*

CORYPHAEUS:

Company, halt!
Screw your papers up into little balls.

Throw them at the man on the second row.

PENTHEUS:

Very good, men. Very good. Now listen carefully: I am sending you on a very important mission, codename 'Red Zebra'.

ARMY:

Oh, red zebra! How exciting! A mission! etc.

PENTHEUS:

All right, all right! Look, we'll talk about it later. Attention!

I want you to bring me this impostor immediately.

ARMY:

Yes, sir! Right away, sir!

PENTHEUS:

Sergeant.

CORYPHAEUS:

Company... Snuggle up! About face!
Company... Skip away!

PAPER ARMY exit.

PENTHEUS sits at desk and waits.

Scene 6

AGAVE:

I think he loves me
I do
Did you see the way he looked at me?
His eyes were only on me
I could feel them, I really could
The other night he touched me
Yes
He walked amongst us
And his skin brushed against mine

He did it deliberately, I know he did

He sees through this skin
To what I am underneath

DIONYSUS gives AGAVE wine.

DIONYSUS and AGAVE exit.

Scene 7

PAPER ARMY re-enter with DIONYSUS.

PENTHEUS:
Well done, men!
Very good!

To DIONYSUS.

So you're the one that's been causing all this havoc.
You're taller than you look in the papers.
What's that smell? Perfume? Not in this city, my friend!
So where did you spring from?

DIONYSUS:
I have come from the far, far east.
Egy hely amit egy ilyen kicsi ember mint te el sem tud
képzelni
Gyönyörü ott
Nem úgy mint ez a kis vacak királyság
Ahol az emberek négykézláb másznak
Egy idióta királysága alatt.

CORYPHAEUS:
It is a place a small man like you could never imagine,
It is beautiful there,
Not like this shabby little kingdom
Where men crawl like ants
Under an idiot king.

CORYPHAEUS places a dunce's hat on PENTHEUS.

PENTHEUS knocks off DIONYSUS' hat and replaces it with the dunce's hat.

PENTHEUS:

Now we'll see who's the idiot!

DIONYSUS:

I do not come from the same place as you.
You come from the dust and will return to it.

PENTHEUS sees DIONYSUS' shoes

PENTHEUS:

Too bloody right, we don't come from the same place!
Look at you in your gold shoes! Bit of a chorus girl, are we?
Do the can-can in those can you?

DIONYSUS reveals his legs…

You've long legs. Like a deer in the forest.

DIONYSUS grabs his crotch.

What are you doing? Pervert!
What kind of man are you?

DIONYSUS:

I am no man.
I am the God, Dionysus.

PENTHEUS:

Let's get one thing straight:
You are not a ruddy God!

DIONYSUS:

Oh, cousin.

PENTHEUS:

Cousin? Don't call me cousin!
You're no cousin of mine!

DIONYSUS:
> Oh, but I am.
> Ez a hely ahol Semele az anyám, a te nagynénéd
> meghalt és én megszülettem.

CORYPHAEUS:
> This is the spot where Semele, his mother,
> Your aunt, died – and he was born.

PENTHEUS:
> Don't bring my family into this!

DIONYSUS:
> Too late.

PENTHEUS:
> Semele and her bastard child perished that night
> Struck by lightning!
> A suitable punishment for her guilt and lies!

DIONYSUS:
> I am no bastard
> My mother no liar
> And I did survive

PENTHEUS:
> All right, all right
> We'll play it your way
> If you were that child
> And you did survive,
> Where the hell have you been all this time?

DIONYSUS:
> With my father, Zeus

PENTHEUS:
> Whisked you up to Mount Olympus did he?
> Bounced you on his knee?

DIONYSUS:
> Nem. Belevarta a combjába.

CORYPHAEUS:
No, Zeus sewed him up inside his thigh.

PENTHEUS:
What?

CORYPHAEUS:
Inside his thigh.

PENTHEUS:
What?

CORYPHAEUS:
His thigh!

DIONYSUS:
A combjába!

PENTHEUS:
This is ridiculous!

DIONYSUS:
Fogadj el annak ami vagyok!

CORYPHAEUS:
Accept me for what I am!

PENTHEUS:
Why, what are you?

DIONYSUS:
Istennek!

CORYPHAEUS:
I am a God!

PENTHEUS: (*To Coryphaeus.*)
What, you're a God?

CORYPHAEUS:
Yes. No. He's a God.

PENTHEUS:
Well I know he's a God –

DIONYSUS:
Ha!

BACCHAE:
Praise Dionysus!

PENTHEUS:
No! He's not a God!
He's insane.

DIONYSUS:
What?

PENTHEUS:
You're insane!
Nothing but an impostor!
A foreigner with ideas above his station!
A religious zealot who may have pulled the wool over
the eyes of this city – But not mine!
I see you for who you really are,
I can see through your tricks and holy fripperies
Preying on the weak-willed
Tempting grieving widows
Luring the young and impressionable
Filling the land with lechery!
You shall be severely punished for these foul-tongued
Bacchic rites!

DIONYSUS:
And you shall be severely punished for your blindness.

PENTHEUS:
You actually believe you are a God.

DIONYSUS:
I am a God.

PENTHEUS:

Perhaps a spell in jail will drive the delusion out of you.

DIONYSUS:

It is not me that is deluded, cousin.

PENTHEUS:

I sentence you to life imprisonment!

PENTHEUS gets chains and a padlock from his desk and binds DIONYSUS' wrists.

I shall bind your wrists tight, and your pretty ankles too.
And the bonds will cut deep.

The cell? Black and windowless!
The door? Twelve inches thick!
And you will be the God of despair!
The God of hopelessness!
God of nothing!
Take him away!

DIONYSUS:

No cell on earth can hold me prisoner.
And I will come for you,
Swiftly, and with great vengeance
You will pay for this sacrilege.
I warn you – it's a very bad idea to put a God in jail.

DIONYSUS is imprisoned.

Scene 8

SONG: 'Atrocities Rap'

BACCHAE:

I wouldn't do that if I were you
Some people just don't have a clue
It's a bad idea to put a God in jail
It's a bad idea
It's destined to fail

TEENAGE BACCHAE:

He commits atrocity with such ferocity
Such virtuosity, this stinking city
Doesn't know what's hit it!
He made the headlines, so print it
Before he takes the biscuit and the cookie jar with it
Dionysus is on the rampage!

Off the gauge
Murdering the world cos it's all the rage
He's pissing in your petrol tanks
He's General Mayhem, so he outranks
You little mortals, who can't control their destinies
You're better off at home with your slippers and recipes
He can't deny the holy rush he got
When he tore your temples down from bottom to top
He's revved right up and on a mission now
Pulled the rug out from under you, and how
He laughed as he knocked you back with a seismic quake
And you wonder why your whole world is starting to shake?

BACCHAE:

I wouldn't do that if I were you
Some people just don't have a clue
It's a bad idea to put a God in jail
It's a bad idea
It's destined to fail

TEENAGE BACCHAE:

He attacked your central nervous system
Led off your firstborn before he kissed them
Before they sank down and drowned
Into a watery grave, they cried
But none were saved – he's not a merciful kind of guy
Cos if you fell into the fire he'd just watch you fry
He ain't Alpha, he's Omega – the end is nigh

Blows apocalyptic kisses goodbye
He is a virus, not so easy to kill
No matter what vitamin pills
You're picking, he will
Grind you down, he can't resist
He's just too pissed
Got the lethal dedication of a terrorist
With no hesitation, your destination
Is a place laid to waste, an infested nation
Riddled with cracks from middle to back
Front and sides while he's fiddled your stack
Of money he will attack!

BACCHAE:
I wouldn't do that if I were you
Some people just don't have a clue
It's a bad idea to put a God in jail
It's a bad idea
It's destined to fail

TEENAGE BACCHAE:
And as your rotting civilisation falls
As Nature calls you in and wipes you out
With a tidal wave sweep you will hear him shout
'Stupid human beings!
Don't you ever get the feeling
That what you're actually seeing
Should be something you're believing?'

*The palace is destroyed in an earthquake as DIONYSUS
frees himself from his chains.*

*THE BACCHAE are terrified and cower; DIONYSUS
emerges from the chaos.*

DIONYSUS:
Don't hide your heads in the dirt, my darlings
There's no need to tremble
There's nothing to fear

The storm is over
I'm here, I'm here…
Shhhhhhhhhh…

I've got you…

BACCHAE:

We were so frightened!
We've been alone before!
But you came along and found us!
Please don't leave us again!
We're lost without you!

DIONYSUS:

I promise
I'll never leave you

BACCHAE:

Praise Dionysus!

PENTHEUS picks his way through the devastation.

PENTHEUS:

Guards! Guards!
You? How the hell did you get out? Guards!
How did you escape?
Answer me!

DIONYSUS:

Control yourself, cousin. You're upset.

PENTHEUS:

You are damn right I'm upset!
And you are not my bloody cousin!
I tied you up and sealed you inside
The most secure prison I had
And yet here you are!
Somebody let you out.
Who let him out?!

DIONYSUS:

I told you – no cell on earth can hold me.

PENTHEUS:

Oh, you think you're so clever don't you?
I am trying to run this country
With some semblance of order
But the palace has come down around my ears
There's chaos at every turn
And to cap it all off I have to deal with you!
Look at all this destruction!

DIONYSUS:

Yes. Isn't it wonderful?
And I'm just getting started.

Scene 9

CADMUS and TEIRESIAS are on their way up to the mountain, singing 'What Does It Matter?'

CADMUS:

Teiresias, let's stop for a minute.

TEIRESIAS:

Yes, let's stop for a breather.

CADMUS:

How about some refreshment: tea or full-bodied red wine?

TEIRESIAS:

Oh, full-bodied red wine, I think.

CADMUS:

Cheers, old boy!

TEIRESIAS:

Cheers, dear friend!

TEIRESIAS receives a prophesy.

Cadmus!

CADMUS:
What is it, my friend?

TEIRESIAS:
You will lose everything!

CADMUS:
Teiresias, my old friend, I already have lost everything!

I am no longer King!
I am no longer encumbered!
And you know what? I couldn't care less!

TEIRESIAS:
No…you do not understand…

CADMUS:
I have lost my youth
I have lost my home
But I will not lose the chance of a lifetime up on that
mountain!
Come, Teiresias!
Next stop: we'll have full fat cream cakes!

TEIRESIAS:
Oh yes, to hell with doctor's orders! Brandy?

CADMUS:
Yes, and Havana cigars!

TEIRESIAS:
Cigars! And crack cocaine is meant to be very good…

Exit CADMUS and TEIRESIAS.

Scene 10

Enter PAM, hysterical and dishevelled. She collapses in a heap.

PENTHEUS:

Pam! For goodness' sake! Whatever's the matter?
Is that blood on you? Look, calm down!
Where's your inhaler?

THE BACCHAE retrieve the inhaler from PAM's bag and give it to PENTHEUS.

He administers it to PAM, then tries to calm her.

Row, row, row the boat
Gently down the stream,
Merrily, merrily, merrily, merrily,
Life is but a dream.
Pull yourself together, get up off that dirty floor.
Now, take a deep breath and tell me what you saw.

PAM screams again. He slaps her and she faints.

Oh Pam, I'm so terribly sorry, I didn't mean to –

Somebody help!

THE BACCHAE all look to DIONYSUS. He wets her lips with wine and she recovers.

PAM:

I found them in the wood, sir…lounging in a glade. Most of them slept, sprawled out on the forest floor. Some drank wine straight from the bottle, others ate oozing honey from a honeycomb…
I should have brought beakers. And serviettes!

PENTHEUS:

Pamela, pay attention. Was my mother there?

PAM:

Yes. At first she didn't see me: I'd concealed myself behind a bush.

PENTHEUS:

How was she – my mother?

PAM:

I'm terribly sorry, sir… She was in a state of casual undress…

BACCHAE:

She's buck naked!

PENTHEUS:

Mother…naked?

PAM:

She must have sensed my presence because she whipped round
And bore a gaze into me that froze my blood!
For a moment, the forest fell as silent as death
Then Agave arched her back and let out an ungodly howl!
Her sisters awoke, and joined in.
The forest curled and shook at the sound,

And then they came for me!

I ran as fast as I could, but I was no match for their formidable speed! The only thing I could do was pray for a diversion, and as I tumbled out of the forest, my prayers were answered!

A field of grazing cattle.

BACCHAE:

Mooooo.

PAM:

Have you ever heard a cow scream?

It's not as funny as you might think.

The women of Thebes plunged their claws into these
poor beasts instead of me.
Cows gouged open like they were made of clay,
Gushing arteries washed the green fields red
Rags of flesh flew, and hung glistening from the trees
Blood dripped. Skin was stripped. Throats were ripped
out
And Agave, the leader of these demented harpies,
Tore the head from a bull with a gristly twist!
She playfully tossed it amongst her gore-soaked
companions
As if it were a beach ball.
Then they danced like nothing I've ever seen
Writhing like snakes on heat
And moving like…like…you know…

CORYPHAEUS:
No. We don't know. Show us.

PAM:
I can't.

CORYPHAEUS:
Yes you can.

PAM:
They danced…like this…

PAM dances awkwardly.

CORYPHAEUS:
You're very good at that.

PAM:
Oh, thank you so much!

She continues dancing, more erotically.

PENTHEUS:
Pamela!

PAM:

Sir, these women are possessed
And the God makes grim demands,
I have seen Dionysus at work
And the power of his faith first-hand.

I stood by and watched this slaughterhouse erupt
An abattoir manned by women I knew
So when friends become butchers I want to ask
'What is the difference between me and you?'

Pam kisses Pentheus.

THE BACCHAE pick up PAM and sing to her.

SONG: 'The Women of Thebes'

TEENAGE BACCHAE:

The women of Thebes
Each one was doing what they do
Day in, day out
Usually the whim of someone else
Dreaming their quiet dreams
When they heard the call

They dropped their
Soup and bread
Kicked off their shoes instead
Left their lovers, sheets and pillows

They ran into the street
The earth beneath their feet
In a fever

BACCHAE:

Anything with a beating heart
Was their dinner
Breakfast
Supper
Anything with a beating heart
Was their lunch

TEENAGE BACCHAE:

 Tell us about it.

MENOPAUSAL BACCHAE:

 I am menopausal
 I'm half way through
 Neither young enough
 Nor totally past it.
 I cry at the drop of a hat
 I burn as pink as a raspberry
 And on cold nights
 I soak the sheets

 There's no dignity
 There really isn't
 But with him, I am not invisible
 He's taken me in his loving arms
 Cooled me with his breath
 And whispered sweet somethings in my ears.
 Me! So, you see, I am his.

TEENAGE BACCHAE:

 Thank you.

 The women of Thebes
 Each one was dancing without a care
 Arms went one way
 And legs went another
 They danced a dance of love
 They danced a dance of despair

 And once you've danced like that
 It's hard to go back
 To a two-step
 A ballroom tango
 And once you've danced like that
 It's so hard to go back
 To the kitchen

BACCHAE:
>Anything with a beating heart
>Was their dinner
>Breakfast
>Supper
>Anything with a beating heart
>Was their lunch

Scene 11

PENTHEUS enters, trying to hide from DIONYSUS who is following close behind…

PENTHEUS:
>Leave me alone. I need to think. Sit down there.
>Put your hands on your head… go on!
>Carnage! You heard what she said – Atrocity!
>This has gone too far and I hold you completely responsible.
>Well? What have you to say for yourself?

DIONYSUS:
>I am a God.

PENTHEUS:
>You – !
>This plague that you have unleashed is spreading like wildfire
>But mark my words – it will be stopped. You have left me no choice but to launch an all-out assault on these maniacs! I will drive your worshippers from the mountains, no matter the cost.

DIONYSUS:
>Figyelmeztetlek, hogy ne fogj fegyert egy isten ellen.

CORYPHAEUS:
>He warns you not to take arms against a God!

PENTHEUS:

One: I'm King – you don't tell me what to do.
And two: You are not a God!

DIONYSUS:

A te szánalmas seregednek nincs esélye,
széttepik öket, mint a rongyot!

CORYPHAEUS:

He says: like the cattle, your armies will be torn limb
from limb!
The soldiers don't stand a chance against the frenzied
might of The Bacchae!

PENTHEUS:

You alone have pushed me to this point
You alone have left me no choice
I am willing to sacrifice both sides,
If blood is spilt, so be it. I'm passed caring whose it is!
This madness must be put to an end, whatever it takes!

DIONYSUS:

You are out of control, cousin
You need to show some restraint

PENTHEUS:

Ha! I'm out of control?

DIONYSUS:

Like all kings, you have no regard for innocence
You wouldn't dare look them in the eye
Before you condemned them all to die!

PENTHEUS:

You're wrong – I'm not that kind of King!

DIONYSUS:

You are exactly that kind of King!
One who likes to keep the real world at bay
One who likes his walls built high
You need to know where one land ends

And another begins
You are a King who must know his boundaries!

PENTHEUS:

A man is lost without them.

DIONYSUS:

No. Without them he is free!
I have done you a favour, cousin.
I have brought these boundaries down,
knocked these walls to the ground.
But still you are too frightened to leave.
Still you hide, feeling safer inside your crumbling palace.
Still you refuse to see what lies beyond with your own eyes.

PENTHEUS:

How dare you! I am not frightened!
I will see whatever you have to show me!

DIONYSUS:

Prove it!

PENTHEUS:

Take me to them. Take me to The Bacchae.

DIONYSUS:

You want to see The Bacchae?

PAM:

Your Majesty, I wouldn't! I've been there…

PENTHEUS:

I want to see their disgusting practices with my own eyes.

PAM:

Sir, they're monsters.

PENTHEUS:

I am not afraid.

PAM:
> They'll kill you.

DIONYSUS:
> You should dress as they do.

PENTHEUS:
> As they do?

DIONYSUS:
> You must be seen to be a believer.

PENTHEUS:
> So be it.

DIONYSUS:
> You are braver than I thought.

PENTHEUS:
> I want to go the mountain.

DIONYSUS:
> And you will. You will.

PAM:
> No sir, you mustn't!

PENTHEUS:
> What should I wear?

DIONYSUS:
> Women's clothes.

PENTHEUS:
> Women's clothes.

PAM:
> Your Majesty!

PENTHEUS:
> I know what I'm doing

PAM:
> Please, sir! Reconsider! Your Majesty!

What about me? Pentheus!

THE BACCHAE carry PAM off.

DIONYSUS lifts PENTHEUS off the ground. THE BACCHAE take off PENTHEUS' shoes.

DIONYSUS takes off PENTHEUS' coat, trousers and vest.

DIONYSUS places PENTHEUS on a stool and removes his pants.

THE BACCHAE bring women's clothes for him and dress him.

DIONYSUS watches.

DIONYSUS:
Tökéletes öltözet a halálra.
Hamis illúziókkal töltöttem meg fejét.
Kár érte – szeretetre méltóan néz ki.
Nemsokára az anyja karjaiban fogja magát taláni,
De nem úgy, ahogy azt ö szeretné.

He is dressed for death.
I have filled his head with wild delusions
He is dressed to be killed, for showing me such arrogance
It is a shame – he looks so lovely.
He shall be going to the arms of his mother,
But not as he would have wished.

To PENTHEUS.

You look like your mother.

PENTHEUS:
Will they laugh at me?

DIONYSUS:
No. They won't laugh at you.

DIONYSUS starts to leave, then pauses.

Before you ask, I do not know mercy
I may have once, but that is another story.

Hölgyeim itt vagyok, kit vihetek magammal,
ezt a kis göndör szemüvegest.

DIONYSUS exits with PENTHEUS.

Scene 12

Music.

AGAVE climbs down the hoarding and comes forward. She is in her underwear.

AGAVE:
Like a snake I have shed
My daughter skin
My mother skin.
My Queen skin.

What have I been doing all my life?
Have I been asleep?

My new skin tingles.
I can hear a lover's untamed sighs
I can feel the twitch of a lion's tail.
I can see what cannot be seen.

No one is safe from what I know.
No one is safe from what I can do now.

My pulse is off the scale.
My heart beats like the pounding sea.
I can do anything.
And I will.

AGAVE dances.

SONG: 'Through A Forest'

BACCHAE:
> Through a forest with too many paths
> He cannot see the sky
> Through a forest with too many leaves
> He cannot see the wood for the trees
>
> In this dark world the hills will drink blood
> The air shivers and the Gods watch us down below

AGAVE exits.

PENTHEUS enters.

> His heart is beating for what he might see
> His heart is beating for what he might be
> Through a forest with too many leaves
> He cannot see the wood for the trees
>
> In this dark world the hills will drink blood
> The air shivers and the Gods watch us down below.

A hand-held light is lowered, and PENTHEUS finds it.

Scene 13

THE BACCHAE run across the stage in semi-darkness.

PENTHEUS catches CORYPHAEUS in a beam of light.

CORYPHAEUS:
> Welcome to the mountain!

Music – an atmosphere of revelry and wild abandon.

CADMUS and TEIRESIAS enter.

TEIRESIAS receives a prophesy.

TEIRESIAS:
> Cadmus!

CADMUS:
I'm here, Teiresias, I've got you!

TEIRESIAS:
We will die very, very old!

CADMUS:
Oh Teiresias, we are already very old.

But will we die happy?

TEIRESIAS:
That I cannot see, just old.

As PENTHEUS watches, a Bacchic orgy ensues.

DIONYSUS and AGAVE party in the shadows.

CHANT:
Nem megyünk mi messzire
Csak a világ végire!

The party escalates.

A lamb scampers in.

It is teased then cruelly taunted by THE BACCHAE, who throw it to AGAVE.

AGAVE tears it to pieces.

PENTHEUS:
Mother, mother! What has happened to you!

AGAVE:
Ezt a kis szart hozzátok ide nekem!

We do not go too far,
Just to the edge of the world!

Scene 14

AGAVE sees PENTHEUS and points him out to THE BACCHAE.

THE BACCHAE surround PENTHEUS. They taunt, bully and assault him.

THE BACCHAE rip off PENTHEUS' clothes.

PENTHEUS:
 I am Pentheus, son of Echion!
 I am your King!

THE BACCHAE pour wine over PENTHEUS' face, beat him and tear his pants off.

THE BACCHAE call to AGAVE. She appears at the top of the hoarding and climbs down.

She is topless, wearing a red tutu and is covered in blood.

THE BACCHAE become monsters.

AGAVE dances a dance of death with PENTHEUS. DIONYSUS watches.

PENTHEUS:
 Mother! It's me!
 Can't you see?
 I am your son, Pentheus!

AGAVE tears PENTHEUS' head off.

Scene 15

AGAVE:
 Kill or be killed!
 Look what these woman's hands can do.
 I will skin this beast and wear its coat as a skirt.

 Look! Look what I've done

This was the fiercest lion in the pack.

And I, Agave, the King's mother killed it.

The only thing I killed before was time!

CADMUS enters.

Father, look. Aren't you proud?
Look at the fear in its amber eyes

We will skin it and hang it on your wall
And you can say to your friends:
'My daughter, the hunter did this!'
Ha! Pentheus will not like it,
He only fights with Gods!
I will show him what his mother can do now.

CADMUS:

Stop, stop! Look what you have done

AGAVE:

It is the best thing I have done
My heart is beating.

This was the King of the beasts and I killed him!

CADMUS:

Look closer, look closer

AGAVE:

Yes! Yes!

CADMUS:

Look closer. Can't you see?

AGAVE:

Yes. Yes, I can see.

CADMUS:

Look!

AGAVE:

(*Cries out like an animal as she realises what she has done.*)
Who did this?
Not me.

Sees the blood on her hands.

Yes me. Me…
They say love is blind.
Yes, that's it, I was blind,
For a moment I was blind. We all were.
But even a blind woman would recognise her son,
So I have not that excuse,
She would know his skin, his smell, his voice

And I did hear his voice, although I thought it a lion's
cry
But in my soul I heard it say: 'Mother, it is I – your son
Pentheus'

But my hands were not my own
And now I cradle his head, but not like I once did.
Not like a mother should. Not like a mother should.
Father, help me…

Scene 16

Earthquake rumble.

DIONYSUS appears as a God in all his glory.

He levitates above the stage.

DIONYSUS:

Things would have been better if you had never been
born.
Mindenkinek job lett volna.

AGAVE:

Ennyi, mást nem mondassz?

My heart is ripping
Can I not touch his flesh
To say goodbye?

DIONYSUS:
There is nothing left of his flesh.
You tore it, remember?

AGAVE:
I did not know it was him
Nem tudtam, hogy Ö az

DIONYSUS:
Nem tudtad?!
How could you not know your own son?

CADMUS:
Please. I beg of you.

AGAVE:
How could I not know? He was inside me. I heard his
first cry…

DIONYSUS:
And his last.

AGAVE:
Please, he was my son! My own precious son!

DIONYSUS:
It was not my hands that warmed themselves in his
blood…

AGAVE:
Stop! What can I do?
I know he is dead, but look what I have done for you.
Teérted csináltam… a fiam, my own precious son!

DIONYSUS:
I don't care.

AGAVE:
> What?

DIONYSUS:
> I don't care

AGAVE:
> Don't say it, don't say it. Help me, please, help me!
> I was wrong. I said I was wrong.

DIONYSUS:
> Did you think that would be enough?
> It would have been better if you had not been born.

AGAVE:
> Könyörgöm… megörülök… megörjitenek a szavaid
> Your words kill me.
> Who will mourn me like I mourn him?
> How can I live? How can I live?

DIONYSUS:
> No one. No one will mourn you.
> It would have been better if you had not been born.
> Senki nem fog eltemetni. Senki.

AGAVE:
> Senki. Senki nem fog eltemetni.
> Jobb lett volna megse születni.
> It would have been better
> If I had not been born.

CADMUS:
> Who is God? You are, Dionysus, you are.
> Some say revenge is sweet. Where is the sweetness?
> Where is the sugary aftertaste? Have you not had your
> fill?
> Has not the slight done to you been repaid?
> Have we not flattered you enough?
> You make refugees of us all
> You make us exiles from each other,

And each other was all we had.
You've made your point.
You've made your point.

DIONYSUS: (*To AGAVE.*)
It would have been better if you had never been born.

SONG:
'It Might Have Been Better If You Had Never Been Born'

BACCHAE:
Senki, senki
Eltemetni
Nem fog téged
Eltemetni senki.

Tán néked
Jobb lett volna
Megszületned
Megszületned sem kellett volna.

Cello plays as AGAVE exits, clasping her son's head to her.

The End.

THE WOODEN FROCK

Foreword: *The Wooden Frock*

I'd seen *The Red Shoes* and been swept off my feet by the emotional force of Kneehigh's theatrical story-telling. Here was theatre that was performed with the simplicity and directness of a child's poem yet could rend your heart with the eloquence of grand opera. I loved it.

I put the meagre resources of Battersea Arts Centre (BAC) on the table and invited the company to create a new show from an Italian folktale. We read hundreds before Emma Rice told Bill Mitchell, Mike Shepherd and me that her favourite was the story of a girl who escaped from her family in a wooden dress, and that she'd read it on the first day.

Emma (whose directorial approach is to urge her collaborators to meet impossible challenges in the knowledge that she will be there to clear up the mess if it goes wrong) then asked me to write the words. Within weeks I found myself at the heart of a theatre-making process quite unlike anything I had experienced. Perhaps this was the secret to the unique Kneehigh style.

We began in a barn in Gorran Haven in Cornwall. The devising team (four actors, a designer, a composer, a lighting designer, Emma and myself) told the story to each other while Emma and Bill evolved a vision for the world in which our play would take place. Act One centred on a comfortable, happy, eccentric family in a land where it never stopped raining; for Act Two, we imagined a bleak, dry, stunted place where just about everything had lost the will to live. We then identified the key characters, brainstormed their defining characteristics (shyness, honesty, cunning, open-heartedness, emotional myopia etc.) and Emma sent us to a costume store to dress each character in turn. Before a word was written Mike Shepherd was wearing a wimple and neat Moroccan slippers and answering to the

name of 'Nursey'. Challenged by Emma to 'go about his business,' he picked up a can of poison and began inspecting the barn for woodworm.

In this way, the characters and the story were cooked up together by the group. As the people of the play emerged, I wrote words for the scenes they were improvising. Some stuck, some didn't, and gradually the dialogue for a first draft of the play took shape.

In parallel with this process, Emma would issue ludicrous challenges to all members of the team. 'I think we all agree that we will need a song to end this scene,' she would say, eyeing composer Stu Barker and me. 'Can you write something by lunchtime? Don't worry if it's rubbish.' Alongside the rubbish (including a call-and-answer jig with the lyric 'Come in Come out Come In Come Out Come In Come Out of the Rain!') we wrote all the songs in the script through this comically abrupt procedure.

As a writer, I was treated in just the same way that Emma treats the actors, or indeed all members of the company. I was asked to produce material, which (under her direction) was then woven into scenes and finally a play. By then, of course, I was enjoying the more conventional chores of rewriting, shaping and editing the show during its rehearsals and previews. But that first workshop – that room full of strange and gifted people cajoled by Emma Rice to explode with ideas and possibilities – produced the most inspiring atmosphere I've ever had the pleasure to work in.

Tom Morris – Writer

Dedicated to Charles Causley

A note on the text:
This show was devised. The text was partly written and partly developed through improvisations. As the show took shape, key moments of story-telling were sometimes found in the text, sometimes in the music, sometimes in the design. In order to preserve the story of the show, this script is largely a record of the production that toured in the spring of 2004. If it were to be remade by Kneehigh or any other company, it might be very different.

A note on staging:
This show was conceived and performed in traverse with an elevated 'bridge' walkway above the stage, accessible from a ladder at each side of the playing area. Underneath the walkway, a red velvet curtain was mounted on a crossbar; it could sweep from side to side across the stage, wiping it as a cloth wipes a slide. It could also divide it, allowing some action to be hidden from both sides of the audience (see Scene 6). A large slatted wooden platform served as the King and Queen's bed, the Nurse's kitchen table and all other furniture in Act One.

Characters

THE KING

THE QUEEN

MARY

NURSE

RONALD

PRINCE

MOTHER

STUPID PETER

REX

CARETAKERS

GEESE

The Wooden Frock was first presented as a Kneehigh Theatre co-production with BAC in association with West Yorkshire Playhouse, in January 2003, at West Yorkshire Playhouse, with the following company:

MARY, Amanda Lawrence
NURSE / PRINCE, Mike Shepherd
MOTHER / STUPID PETER, Bec Applebee
RONALD / PRINCE'S MOTHER, Alex Murdoch
FATHER / REX, John Surman
MUSICAN, Stu Barker

Directed by Emma Rice
Written & Adapted by Tom Morris & Emma Rice
Designed by Bill Mitchell
Music Director & Original Music, Stu Barker
Lighting Design, Alex Wardle
Costume Design, Emma Rice with Vicki Mortimer
Production Managers, Suzi Cubbage & Alex Wardle
Stage Manager, Jack Morrison
Technical Stage Manager, Rachel Bowen
Video Design, Mic Pool
Dance Trainers, Gary & Sarah Boon

Set, props and costumes built by West Yorkshire Playhouse.

Nominated for TMA Theatre Award, Best Touring Production 2004.

Act One

Pre-show: The company, dressed as CARETAKERS, wander about in the auditorium. They are fascinated by any spill or dirt that they find. They talk to the audience and each other; 'watch out it's a bit mucky down there', 'that's a disgrace that carpet', etc.

There is a thunderclap and the sound of rain. The CARETAKERS assemble onstage under an umbrella.

'Didn't It Rain' (as recorded by the Galilee Singers) is played on the P.A.

The CARETAKERS carry handfuls of planks onto the stage and build a big bed. They dance.

Thunderclap.

Scene 1: The Happy Family

The KING and QUEEN's bedroom.

This is the main social room of the house. The NURSE, the KING, the QUEEN and MARY are assembled on the stage around the bed. The NURSE is listening to the gutters.

NURSE:

What a storm! At least the guttering's strong and we're all cosy for the night.

Enter RONALD stirring a mug of tea, with a pigeon concealed in his clothes.

RONALD:

The pigeons are settled, Sir. Safe and Sound. I'll take this one up a bit later.

NURSE:
Oh Ronald!

The QUEEN is looking at MARY.

QUEEN:

> Come on, my little princess. Say goodnight to Mummy.
> It's time for bed.

MARY:

> Can I stay up a bit longer?

KING:

> You can have your story in here.

*The NURSE brings the book to the bed. RONALD sidles up
to listen to the story.*

NURSE:

> Excuse me, Sir – is there time to deal with that little bit
> of woodworm?

KING:

> Of course.

NURSE:

> Ronald. Fetch me my Barrett's liquid, would you?

KING:

> Once upon a time, there was a happy, happy, kingdom
> where the rain came down in great gushing torrents,
> roaring cataracts, yelling down for days and nights on
> end like the howl of a giant diabolical dog.
>
> And in this kingdom lived a very, very, very happy
> family indeed. They lived and worked and played
> together like the happiest children you can imagine,
> even when the rain was murdering itself in sheets against
> the windows and hurling through the gutters like
> stampeding cattle.
>
> And the reason for the happiness of this family was the
> Queen, who was the most beautiful, the kindest, the
> gentlest, the most loving woman that anyone had ever
> known.

*The QUEEN sings 'I can't give you anything but love' by
Dorothy Fields and Jimmy McHugh. MARY and then the
company join in.*

QUEEN:
I can't give you anything but love, baby
That's the only thing I've plenty of, baby
Dream awhile, scheme awhile, you're sure to find
Happiness, and I guess, all those things you've always
pined for
Gee I like to see you looking swell, my little fat baby
Diamond bracelets Woolworth's doesn't sell, baby
Till that lucky day you know darn well, baby
I can't give you anything but love.

The NURSE fixes the book onto flying lines. It flies out.

KING:
Goodnight darling.

*The NURSE carries MARY out leaving the KING and
QUEEN alone on the bed.*

Scene 2: The Promise

The KING and QUEEN's bedroom.

The action flows from Scene 1.

KING:
Now sing me a song.
Sing me the song you sang when I first saw you.

*The QUEEN sings. The NURSE checks the bed is secure
and crawls underneath it to attack the woodworm. RONALD
sips his tea.*

QUEEN:
The morning sun
Is quickly gone
A lover's vow

Is just for now
The darkest night
Is put to flight
A child's care
Turns into air
But my man will remember me

I've got my man
And he'll always remember me
My lovely man
As faithful as he could be

The hills will fall
However tall
And seas have dried
Though mighty wide,
The warmest smile
Lasts but a while,
And love is cold
When it is old
But my man will remember me

QUEEN:
Will you love me forever?

KING:
Of course I will.

QUEEN:
But what if I died?

KING:
What do you mean what if you died? You're not going to
die. Not before me, anyway.

QUEEN:
What if I do die first? You'd be on your own with Mary.

KING:
Don't be so morbid. Live for the moment, that's what
you always say.

QUEEN:

I'm just thinking that if I did die – and I'm sure I won't – then you'd be on your own with Mary and it might be a good idea for you to get married to someone else.

KING:

I wouldn't marry anyone else

RONALD:

I would.

NURSE:

What, Ronald?

Pause.

RONALD:

If I was married and my wife died... I would marry again.

NURSE:

Oh Ronald.

KING:

You're all I ever wanted. All I ever want. You know that.

QUEEN:

I want you to make me a promise.

KING:

Okay.

QUEEN:

Promise me that if I die before you –

KING:

– which you won't –

QUEEN:

– and if you do decide to marry again –

KING:

– which I won't –

QUEEN:

– that you'll let me choose who you marry.

KING:

What do you mean?

QUEEN:

That you'll only marry the person who fits this ring.

KING:

That's our wedding ring.

QUEEN:

Will you promise?

KING:

I don't want to.

QUEEN:

Just for me. Promise.

She kisses him.

KING:

Alright. I promise.

The KING and QUEEN make love while the NURSE and RONALD go about their business.

RONALD:

How's that woodworm, Nurse?

NURSE:

Just giving it a dose of the Barratt's liquid, Ronald.

RONALD:

You swear by that Barratt's liquid, don't you Nurse?

NURSE:

The only good woodworm is a dead woodworm, Ronald. Oh look – they're going to sleep. We'd better give them a bit of privacy. Come along, Ronald: night chores.

NURSE and RONALD leave.

Scene 3: Nurse's Kitchen

NURSE's kitchen.

The NURSE carries tools, random cooking equipment, mole traps etc. in a wooden tool tray.

RONALD is standing on the kitchen table (previously the bed) with his trousers down and his underpants on. NURSE is sewing a penny into his underpants.

MARY: (*Offstage.*)
Nursey! Where are you?

NURSE:
In the kitchen. You're late for your lesson.

Enter MARY.

MARY:
What are you doing, Nursey?

NURSE:
I'm sewing a penny into Ronald's pants. I'm doing it for all the family.

Holds up another penny.

This one's going into yours. That way you will always have a penny while you've got your pants on.
Now, my little swallow, tell me what you saw in the garden this afternoon…

MARY:
I saw a weasel.

NURSE:
Ah! The clear eyes of the weasel. Ever alert, Mary. Always be on guard.

During this sequence, NURSE attacks and MARY practices her self-defence moves. First, she attacks the eyes. MARY successfully defends.

Very good.
And the forearm parry.

NURSE aims at the head. MARY blocks.

And the scissor chop.

NURSE aims at the bread box. MARY blocks with a scissor chop.

Very good. And the one two three. Ha! Ha! Ha!

Next, Mary: dancing.

There's only one way to dance without losing one's dignity. Let your dance flow from the natural rhythm of your walking

Shows her the step.

You see? A shin-high kick – and release.

MARY joins in. They dance.

Good. Now. How do you recognise an honest woman?

MARY:
She knows her name and she does what she likes.

NURSE:
And when entering a room?

MARY:
Always lead with the left hip

MARY demonstrates.

NURSE:
and

MARY:
never smile at the food.

NURSE:

That's right, Mary – save your smiles. Don't waste them on a pork chop. And what is the most vulnerable part of the body?

MARY:

The heart?

NURSE:

No Mary. The shin. Look at Nurse's little razor. Not an ounce of protection on it.
Remember the dance of the Frilled Lizard.
Watch the lizard dance…
Distraction. Distract your opponent.
Distract and attack.

The NURSE distracts MARY with a frilled lizard dance: MARY responds by distracting NURSE. MARY floors NURSE.

Good. The same principle may be used, my swallow, with animal noises.

MARY:

Sorry?

NURSE:

A judiciously used dog-howl or even a goose-hiss can be very effective in unsettling an opponent.

NURSE demonstrates. They make noises at each other.

RONALD:

Look. He's laid an egg. A beautiful pearly-white egg.

NURSE:

What a clever pigeon. We'll have that for an omelette.
For an omelette isn't one dish, Mary. It's five hundred.
If you can cook a good omelette, there's nothing you'll want for in life.

They go out.

RONALD:

> I love my pigeons. They keep you happy.
> The Queen brought them first – not for racing, just for the way they are.
> I love him.
> See him? He's a beauty.
> He lifts me up when he flies.
> I watch him and I feel as happy as a King.

There is scream from offstage.

Scene 4: The Death of Mother

The KING and QUEEN's bedroom.

A scream of pain from the QUEEN is heard offstage. The KING and QUEEN enter. The KING helps QUEEN onto the bed. MARY comes in. The KING calls for NURSE to take MARY away. MARY struggles with NURSE.

We see the QUEEN dying horribly.

KING attempts to care for her and to restrain her. NURSE gets MARY out of the room. The QUEEN goes still. The KING sends everyone out of the room.

Scene 5: The Laying Out of the Body

The KING and QUEEN's bedroom.

NURSE enters and gently straightens and tidies up the body, adjusting the clothes and removing the DEAD QUEEN's jewellery which she places in a box and gives to the KING. MARY and RONALD stand at either end of the bed. The company sing:

COMPANY:

> Sister, my sister
> Lie here beside me
> While the cold wind blows

Until the night is gone
Lie here
And I will keep you warm

The DEAD QUEEN gets up, takes off her dressing-gown, and walks around looking at the members of her family. They can't see her. They sing.

Sister, my sister
Lie here beside me
While the wild sea roars
Until the night is gone
Lie here
And I will hold your hand

Sister, my sister
Lie here beside me
While the silver moon shines
Until the dawn is come
Lie here
And I will be your eyes

The DEAD QUEEN climbs up the ladder and onto the bridge, observing the rest of Act ONE from above. The KING leaves, carrying the jewellery box.

Scene 6: The Replacement Queen

The town square.

NURSE and RONALD enter and look about. The audience are the townspeople.

NURSE:
Now Ronald.
Remember to keep your wits about you.
The general public are normally harmless, but beware that in every crowd lurks an individual.
Keep scanning left and right…
Any signs of individuality?

RONALD:

No.

NURSE and RONALD jump up onto a platform to address the audience.

NURSE:

Greetings…all you potential Queens
And thank you for responding this afternoon.

RONALD:

Evening.

NURSE:

This bright and sunny afternoon heralds the end of the King's period of mourning.

RONALD:

Afternoon.

NURSE:

Mourning.
We ask you to insert your ring-fingers – all of you – into the air.
Thank you for your co-operation.
Scan the crowd, Ronald. I think they're turning ugly.
The King approaches. Raise your fingers high
Whomsoever's finger fitteth the King's ring shall be our New Queen.

The KING enters and makes his own speech.

KING:

Thank you. I have made a difficult decision this morning. The person whose finger fits this ring will be my new wife.

The curtain is pulled across the stage, dividing the KING from the NURSE and RONALD. Half of the audience can see the KING; the other half can see the NURSE and RONALD.

NURSE and RONALD invite members of the audience onto stage to try the ring; none of them fit.

NURSE: (*ad lib.*)

Settle down please, ladies…form an orderly queue… don't worry madam, this curtain will protect your anonymity… If you wouldn't mind inserting your finger into the King's ring… Your majesty we've got a lovely one here… etc.

On the other side of the curtain, the KING talks to the audience.

KING: (*ad lib.*)

As you can see, we've taken every precaution to avoid embarrassment… It was my wife's dying wish, you know, to find a new Queen like this… Don't worry you'll be able to have a go in a moment… etc.

A member of the audience tries on the ring through the curtain. It doesn't fit. The curtain is rotated, so the each half of the audience get to see the other half of the routine.

This is repeated two or three times. Each time the finger is too fat, too thin, too hairy etc. Eventually the NURSE and RONALD put their own hands through the whole, building into a picture of grasping hands.

No, no… Stop!
Thank you very much everybody for coming –
but please, everybody, just go home.

The KING leaves.

NURSE:

What a disappointment for him.
What a shame. Not a Queen amongst you.
Oh it's too late now, Sir.
If one of you had fitted the King's ring, we could have been home by half nine with a guaranteed happy ending…

All I can say is – who knows what will happen now?

RONALD:

You've ruined it.

NURSE:

Months passed.

And as the months passed, fewer and fewer hands came to try on the ring – until one day there were no hands at all and a strange peace descended over the kingdom.

Exeunt.

Scene 7: Finding the Ring

The KING's bedroom.

The KING comes into the bedroom with the ring. He holds it up and puts it back in the box. The DEAD QUEEN sings 'I've Got My Man' from the bridge (reprised from Scene 2). The KING leaves, and MARY comes in to the room.

Tentatively, she unveils her mother's dresses. She drinks them in. She tries one on – and the shoes. She sits on the bed, lies back on the bed, swinging her legs the way her mother used to. She finds the ring box – and tries the ring on... The KING calls from offstage.

KING: (*Offstage.*)

Mary! Mary! Where are you, Mary?

MARY tries to remove the ring. It won't come off. The KING enters. He notices the dresses, but not the ring.

KING:

Mary. There you are.

Don't play with Mummy's clothes. It's time for us to forget.

MARY:

I'm sorry, Daddy.

MARY backs away from him.

KING:

What is it, Mary?

MARY:

It's nothing.

KING:

No darling. You can tell me.
Has something happened?
You can tell me.

Pause…

MARY:

I.…

MARY tries to leave. The KING catches her gently by the wrist.

KING:

Mary?

He sees the ring. The DEAD QUEEN speaks from above.

QUEEN:

'Only marry the person who fits this ring.'

KING:

Of course. How simple. It's you.

MARY:

Daddy?

KING:

Her arms. Her face. Her body. You're the one I must marry.

He kisses her.

KING:

My little Mary.

He kisses her again.

KING:

Don't worry. It feels strange now. But it will feel alright.
Wait here. I'll go and make the arrangements.
It is what is meant to happen.

He goes.

MARY wipes her mouth. Above, so does the DEAD QUEEN.

Scene 8: The Nurse Hatches a Plan

The KING's bedroom (continuous from Scene 7).

MARY:

Nurse! Nurse!

*Storm. Thunder. Lightning. Percussion crashes. The NURSE
and RONALD, with pigeon, run around the frame of the set.
The NURSE arrives in the bedroom.*

NURSE:

There there. Cuddle Nursey. You cuddle Nursey. There's
my little swallow, my little lizard. There's nothing so
dangerous as a cuddle won't take the edge off. You're safe
with Nursey. Good. Now slowly and carefully tell me
what's happened.

MARY shows the ring.

MARY:

I tried on the ring. I was in the bedroom, with Mummy's
dresses…and it wouldn't come off.

NURSE:

Did your father see you?

She nods

MARY:

He kissed me…on the mouth. He said I was the one he must marry. He said it was meant to happen. I don't want to marry him. Nurse, I don't want to marry him.

NURSE:

My love. My love.

Concentrate Mary. Think of the clear eyes of the weasel in the woods. Think of the gentle purring of Nurse's lathe. Danger looms like a thundercloud now, but with the right wind, all will be clear again.

Let's count your limbs:

one, two, three, four – are you all there? Yes you are!

First things first. Let's both have a corner of Nurse's emergency extra-dark chocolate.

They have a bite. MARY coughs.

Don't choke.

Now let's think.

What did Lawrence the Unruly do when he discovered that his sister was about to cook up his children in a pie?

MARY:

I don't know.

NURSE:

He played for time.

Come on Nursey, focus.

And what did Clive the Woodman and your very own Nursey do on that dreadful day when we were caught down at Almond's Well doing something we shouldn't?

MARY:

Play for time?

NURSE:

Exactly.

And what are we going to do?

MARY:

Play for –

NURSE:

I've got it.

Imagine the most beautiful dress anyone has ever seen. So beautiful, no-one could ever find it or make it.

She imagines

What is it like?

MARY:

A meadow.

NURSE:

Good. Tell the King, your father, that you will marry him.

MARY:

No Nursey –

NURSE:

But tell him that for the engagement party – you will need the most beautiful dress anyone has ever seen. Tell him it must be the colour of meadows – every tint and every shade of green – and with every plant and every flower in the world.

MARY:

I don't understand.

NURSE:

This dress, Mary, will be many many months in the finding – if it is ever found at all – and in those many many months, who knows what might happen to the world?

Tom Waits' 'Grapefruit Moon' plays. NURSE tucks MARY into bed.

Scene 9: The Waiting

The KING's bedroom.

RONALD and NURSE are on the edge of the space.

NURSE:
> Ronald, what a fantastic opportunity to travel the world. Don't worry about us if you never come back. Nobody will miss you in the slightest.

He leaves, walking about the audience.

> Now Nursey must earn her bread and butter, with a plan so outrageous, no-one would think it possible.

RONALD:
> Excuse me Sir, I'm looking for a dress… (etc.)

The NURSE enters the bedroom and starts to dismantle the bed, taking it away piece by piece. We hear the sound of sawing and hammering from her workshop, offstage. The KING performs a magic trick to MARY. The NURSE returns.

KING:
> Any news of Ronald?

NURSE:
> Oh Sir, he's been gone so long, I fear the worst.
> No Ronald, no dress, no engagement, no wedding

Bagpipes play. Enter RONALD with the dress. RONALD dances.

RONALD:
> I have the dress. Yes! I have the dress.

KING:
> Well done Ronald.

Everyone is still. MARY crosses to RONALD and stamps on his foot. The NURSE draws curtain across, dividing the space.

On one side the KING addresses his people with RONALD at his side. On the other, MARY and the NURSE hatch a plan.

KING:

Wonderful news! My dear people. Thank you. This is a great day. Our waiting is over. Ronald has found the beautiful dress – which my new Queen will wear to celebrate our engagement. What's it like Ronald?

RONALD:

Oh it's beautiful. I don't know who your wife is, but she's going to look gorgeous.

MARY:

Nurse!

NURSE:

Calm Mary. Think of the clear eyes of the weasel in the woods.

MARY:

Play for time?

NURSE:

Think of a second dress.

MARY:

A dress like the sea, with every fish and frond, every tint and shade of blue, every bubble of foam and glow of coral.

NURSE:

So, for the announcement of the wedding banns, you will have a second dress.
Go on. Tell him.

The NURSE rotates the curtain, leaving the baffled KING with MARY – and RONALD with the NURSE.

KING:

There you are my darling. It's your engagement dress, just as you asked for.

RONALD:

Hello Nurse! We've been all the way to Bradford, I need a cup of tea.

MARY:

Thank you Daddy.
But I need another one –
an even more beautiful
one for the announcement
of the wedding banns, a
dress like the sea, with
every fish and fro –

NURSE:

Really Ronald, well there
are many more places in
the world and we need
another dress. Here's a
drawing. Now get on with
it.

KING:

Of course my darling. You shall have it.

The NURSE sweeps the curtain aside, revealing the whole stage.

KING:

You know what you're doing. Go!

On his way out, RONALD asks the audience for directions etc.

The KING performs his second magic trick. The NURSE takes away more of the bed. There are more sawing noises from offstage. The NURSE returns.

KING:

Any news of Ronald?

NURSE:

Sir, I have been following the shipping forecasts
recently, and I fear he must be lost at sea. No Ronald, no
dress, no wedding banns, no wedding, Sir!

Bagpipes play. Enter RONALD with the dress.

RONALD:

I have the dress. Yes! I have the dress.

*Everyone is still. MARY crosses to him and jabs him in the
eyes. The NURSE draws across the curtain to divide the
stage again.*

KING:

Wonderful news! This is a great day. Our waiting is over. Ronald has found the beautiful dress – which my new Queen will wear to celebrate our engagement. Ronald, what does it look like?

This will be interspersed with:

RONALD:

It's the most beautiful dress you've ever seen Sir…

MARY:

Nurse!

NURSE:

Calm Mary. Think of the clear eyes of the weasel in the woods. We just need to play for more time for Nurse's plan. Think of another dress.

MARY:

A dress like the sky… with every shade of light and dark, every tiny star and winking planet.

NURSE:

Go on. Tell him.

The curtain swivels.

KING:

There you are my darling. It's your engagement dress, just as you asked for.

MARY:

Thank you Daddy. But I need another one – an even more beautiful one for the announcement of the wedding banns. A dress –

KING:

Of course my darling. You shall have it. Go Ronald! And be quick about it.

On his way out, RONALD talks to the audience.

RONALD:

Hello Nurse! Me and the pigeon have converted to Buddhism!

NURSE:

Have you really, Ronald? Well there are many religions in the world. We need another dress. You've got the idea by now. Doesn't matter what it looks like because you'll never find it.

The KING begins his final trick.

NURSE:

Come on, Nursey. Focus. Time is short

*The NURSE takes more bed parts away, returns and measures
MARY's waist and back.*

KING:

Any news of Ronald?

NURSE:

Oh Sir! What with the plague, I fear that Ronald has
most certainly passed away. And all we may hope for is
that his pathetic remains are sent home to us, Sir. No
Ronald, no dress, no wedding, Sir!

Bagpipes play. Enter RONALD with torn underpants.

RONALD:

Ha! They took the penny!
But I have the dress. I have the dress!

KING:

Well done Ronald – my most treasured and loyal
servant. My dear people. Thank you. This is a great day.
Our waiting is over. My daughter and I will be married
this evening. My darling. Take this dress, with every
shaft and beam of light of every tiny star and winking
planet. It is time to put it on.

He goes to kiss her. The NURSE intercepts.

NURSE:

First things first. Bath time!
Fetch your bath, Mary.

The KING is open-mouthed.

And Sir, how about a small piece of Nurse's emergency
extra dark chocolate?

MARY gets the bath.

Don't worry, Sir.
I shall have her scrubbed up like an angel for you in no time at all.

The NURSE draws the curtain, to hide the bathing from the KING.

KING:
This is the happiest day of my life.

The KING puts his head through a hole in the curtain to look at his daughter.

NURSE: (*To the KING.*)
Ladies only, Sir.

Scene 10: The Escape

The bathroom.

NURSE pours the bathwater into the bath and slaps the water to make splashing noises.The KING is behind the curtain, listening and waiting. The DEAD QUEEN is above.

NURSE:
I need something that makes the noise of a little girl in the bath.
Ronald. Bring me the pigeon!

RONALD holds the flapping pigeon in the bath.

KING:
I can hear you splashing in the bath, my little one, my love.

QUEEN: (*Sings, above.*)
I've got my man etc.

NURSE:
Take your clothes off, Mary.

The NURSE indicates to MARY to keep her clothes on.

Now you'll see what Nursey has been busy with all these months.

Exit the NURSE.

KING:
I'm so happy, my little sweetheart. I've waited so long.

The NURSE comes back with a magical frock, made entirely of wood. RONALD is still gently splashing.

NURSE:
Put it on. Put it on.

They look at it. The NURSE knocks on it.

No one can hurt you now.

The NURSE gives MARY the three dresses.

Take these.

MARY:
I don't want them.

NURSE:
They are yours, Mary. Take them with you.

She takes them.

MARY:
Bye bye Daddy

NURSE:
Run Mary, run. Run to the sea!

NURSE and MARY run.

Run like the wind, Mary. Run to the sea.

MARY:
I love you Nursey.

NURSE:

You are Mary Woodenfrock and you can do what you like.

The NURSE looks out towards MARY, who is running to the sea.

KING:

Are you nearly ready, my darling?
I'm coming in, whether you're ready or not.

RONALD looks down and notices that the pigeon has stopped moving.

Mary? Mary?

The KING opens the curtain and sees only RONALD and his dead pigeon.

The gutters crashed, the slates fell and the last broken pieces of that happy happy family were washed away into the still silent sea.

MARY:

Nursey! Nursey! It floats! I'm floating on the sea!

Interval.

Act Two

Scene 11: Sea Scene

The CARETAKERS assemble.

Blackout.

Sound of the sea.

An image of the churning sea is projected onto the floor.

A bath is brought on and is filled with water from a watering can.

'Didn't it Rain' plays.

A puppet of MARY in her wooden frock walks along and steps onto the surface of the water.

A cloth appears with a side view of MARY's frock walking on water. The projected image changes to an underneath view.

Fish appear and swim around.

Enter MARY. She walks on water. There is a savage edge to her physicality – she fights for her survival.

MARY catches a fish, takes a bite out of it, turns and exits.

Scene 12: Cricket

Near the sea in a distant land.

Enter PETER. He starts to mark out his run. REX the dog arrives and is tickled by PETER.

PETER:
Rex! Good boy, Rex. There's a good boy.
He's lovely isn't he?
Rex: sit!

REX sits in the audience. PETER continues to mark out his run.

Enter the PRINCE. He practices some defensive shots.

PRINCE:

Come on Peter, we've only got half an hour before the tide comes in.

He talks to himself.

Now then, Sir – Occupation of the crease. That's the priority. No way through.

He looks up to take guard.

Middle and leg please, Peter.

REX walks onto the pitch.

Dog on pitch!

PETER:

Oh Rex!

PETER starts to mark out his run again. The PRINCE scoffs. PETER bowls. The PRINCE plays an immaculate defensive shot.

PRINCE:

That's it, Sir. Perfect! Perfect!
You will never get me out. You will never never never get me out.

Enter the MOTHER.

MOTHER:

Good grief, you'd bore the pants off a goldfish.

PRINCE:

He hasn't got me out for nine years, mother.

MOTHER:

You are a living daily disappointment to me. I just don't
see how you can misunderstand the game so completely.

Rolling her eyes at PETER.

Come on

Let Mummy show you how it's done.

Pick it up as if it's an axe.

Feet apart. Arse out.

Feel the blood rushing from your heart to your hands.

Christ! You've got to have a bit of flourish in life.

See the whites of his eyes.

and

WAHOOOOLEY!

Over the pavilion into the next field.

That's what your father would have done.

That's what Buffy would have done. Isn't it, Peter?

How's the dog? Come on Rex. Good boy.

She is wrestled to the ground by the dog.

MOTHER:

Get him off me!

Time for a gin and tonic.

You young people just don't know how to enjoy
yourselves, do you?

The MOTHER leaves. The PRINCE is looking out to sea.

Scene 13: The Hunt

Near the sea (continuous with Scene 12).

PRINCE:

What's that?

PETER:

It's a fish.

It's a boat.

It's a tractor.
It's moving like an animal.
It looks like a crab.

PRINCE:
Send the dog in!

PETER:
Rex: fetch!

MARY is aggressively rounded up and captured. She hisses.

PRINCE:
Who are you?

PETER:
I am Peter.

PRINCE:
What are you?

PETER:
I am a human being.

PRINCE:
What do you want?
Shut up Peter.

No reply.

Where do you come from?

PETER:
I live here.

PRINCE:
Peter. Sit down.
We have seen each other every day for the last twenty-
seven years.
I know who you are. Today we have a visitor. For once in
my life I have the opportunity to interact with someone
new.
So Peter, just shut up.

MARY:

I am Mary Woodenfrock, and I do what I like.

PRINCE:

What?

MARY:

I am Mary Woodenfrock.

PETER:

It talks. It talks. It talks.

PRINCE glares at PETER.

PRINCE:

Where do you come from?

MARY:

Over the sea.

She makes as if to go.

PRINCE:

Wait…you could stay.
You could look after my geese.

MARY:

I do what I like.

PRINCE:

Would you like to look after my geese?

MARY:

Yes I would.

PRINCE:

Come on then. Follow me.

They leave.

Scene 14: Mother Remembers Buffy

The MOTHER's house.

MOTHER:

Nothing wrong with a strong gin and tonic first thing in the morning.

Seem to be out of tonic. Never mind.

Make do and mend – like life without Buffy.

Swigs on the gin.

How did a stallion like Buffy end up fathering a ferret like my son?

Skulking about the house like a liberal.

'Pick your ruddy feet up!' Buffy would have said.

Ah Buffy! He was huge!

Do you know, we honeymooned in Norway for a month.

It was November.

That was Buffy all over.

We'd get up when it was still dark and ride like the wind down to the fjords.

It was freezing.

The snow was blowing upwards and we couldn't breathe.

Fantastic!

We'd get to the lodge and he'd wheel the tin bath out in front of the fire.

'Get your combinations off, Bunny,' he'd say. That's what he called me.

Then he'd rub me down and we'd have vigorous sex.

Don't mind if I do, Buffy…

Dances with imaginary Buffy.

He was a colossus – and I'm a big girl.

Goes to slide projector. Shows slides of youthful happy couple.

I remember Buffy

With his pith hat and his whistle
And his appetite for gristle
And his strong but silky extra cover drive
Yes, I remember Buffy
With his shoulders and his whisky
And his wink when he got frisky
When I think of him, by God, I feel alive!

What should we do about him, Buff? What should we do
about our son?
I've said it before and I'll say it again:
He needs a bunny.
A spirit to mix with. Ha ha that's rather good…

Exit.

Scene 15: The Goose Run

The goose run beside the mother's house.

Enter GEESE.

GEESE:
Where does this odd girl belong ong ong ong ong?
Something about her is wrong ong ong ong ong
She's strange but she needs to be strong ong ong ong
Ong ong ong ong ong

MARY:
The very last thing my Nurse did
Was cradle me in a shell of wood.
If she were here, she'd count my limbs
And count them sure and good.

GEESE:
She's lovely but something is wrong ong ong ong ong
Perhaps one day soon she'll belong ong ong ong
She's strange but she seems to be strong ong ong
Ong ong ong ong ong

MARY:

Are you there, my fingers?
Are you there, my toes?
Are you there, my knees?
Are you there, my nose?

MARY tries to climb a tree in her frock. It is difficult.

GEESE:

She's lovely but something is wrong ong ong ong ong
It's starting to feel like one day she'll belong ong
It helps to be strange if you want to be strong ong
Ong ong ong ong ong

Enter PRINCE.

PRINCE:

Do you mind if I –

MARY:

No. It's fine.

PRINCE:

It's just nice coming here in the afternoons.

MARY:

Yes.

PRINCE:

I thought you might like to…

MARY:

Yes.

They throw the ball to each other.

PRINCE:

If you want to move the ball off the seam, you grip it
like this. See?
I'm a seam-bowler, me. Not express pace. Just line and
length. Moving it just a whisper in or out. My Dad
called me 'the metronome'.

They continue to play ball

PRINCE:

There's going to be a dance this evening
Mother's arranged it.
She's trying to find me someone to marry.
I thought she'd given up years ago.
I certainly have.

MARY:

Can I come?

PRINCE:

What?

MARY:

Can I come to the dance?

PRINCE:

Ha! You?!

PRINCE mimics MARY in her awkward dress.

Don't be ridiculous! No.

He breaks the bat.

Now look what you've made me do!

Exit PRINCE. MARY goes over to the GEESE.

MARY:

I am Mary Woodenfrock and I do what I like.

MARY takes a dress from her rucksack. Exeunt.

Scene 16: The Ball

A drafty village hall, poorly kitted out for a party. 'Sugar in my Bowl' sung by Nina Simone plays.

The PRINCE is alone. No-one is arriving. PETER hangs a festoon.

PRINCE:

Surely life can't be so meaningless.

MOTHER enters, comes over and gives the PRINCE Buffy's pith hat.

MOTHER:

Son! Here. Wear your Daddy's hat.

PRINCE:

I don't look like him
I don't talk like him
I don't think like him
I don't walk like him
I wish I was somebody else

I'm turning into a sad old bastard
Day by day
As sure as a leaf turns into compost
As sure as dust blows
As sure as bone whitens
I'll turn into a sad old bastard soon enough
Stuck under my father's hat
While the tide of my life goes out for ever.

Enter MARY. There is silence.

MARY:

Hello.

ALL:

Hello.

There is a stillness.

MARY:

Is there no music at this party?

'Steam Heat' sung by Ella Fitzgerald plays.

MARY:

Would you like to dance?

PETER:

Yes please.

PETER walks over to MARY and drapes himself on her shoulder. The PRINCE is still. The MOTHER is stuttering outrage. 'Oh, for goodness' sake!' MARY quietly lifts PETER's hands off her and pushes him towards the mother. The MOTHER grabs him by the trouser strap and pushes him to the dog.

The PRINCE and MARY are facing each other. They begin to dance.

The music finishes. MARY drops her ring. The PRINCE picks it up to give back to her.

PRINCE:

Your ring. You've dropped your ring.

MARY:

It was my Mother's… You can keep it.

PRINCE:

Keep it?

MARY:

Keep it!

She runs away.

PRINCE:

Whoa!

MOTHER:

What a girl! What a girl! Who was she?

PRINCE:

I don't know, Mother… I didn't ask.

MOTHER:

What? Find her! Find the lady!

ALL:

Lady! Lady!

Scene 17: The Chase

PETER and MARY centrestage. MARY is trapped.

MARY does her defensive moves.

PETER:
> The Prince wants to know who you are.

> *She takes out the penny from her pants and holds it up to the light. PETER is mesmerised. She drops it and PETER stoops to pick it up. She escapes.*

> Lady! A Penny… How could I have been so stupid?

PETER:
> Lady! Lady!

Scene 18: The Goose Run Again

The goose-run.

Enter GEESE.

GEESE:
> This lovely girl needs some more of our song ong
> They've danced at the ball and the feeling is strong ong
> But feelings like that can't stay hidden for long ong
> Ong ong ong ong ong

MARY:
> Are you there my ankles?
> Yes you are
> Are you there my thighs?
> You're there
> Are you there my neck,
> My spine, my heel?
> Are you there my eyes?
> You are.
>
> Are you there my elbows?
> Yes you are

Are you there my shins?
You are
Are you there my sides,
My hands, my cheek?
Are you there my skin
Yes, yes, you are!

Enter PRINCE.

PRINCE:

Last night I saw a woman,
Not just any woman,
A beautiful woman – she danced with me.
Have you seen her?

MARY:

No.

PRINCE:

She was quite a woman,
Really quite a woman,
If only you'd seen her…

MARY:

No women here. Only me.

PRINCE:

I know, I know. Stupid of me. How are the geese?

MARY:

Fine. Would you like to play cricket?

PRINCE:

No. Not today.

Enter MOTHER

MOTHER:

Son! Son! There you are!
What a fantastic party! I was sick three times, fell in a
hedge and woke up in bed with the lurcher.

Buffy would have been proud!
Have you been telling Judy Woodenpeg about it?

PRINCE and MARY:

Mary.

MOTHER:

Whatever. A real smasher turned up out of nowhere –
and we're going to have another party tonight to lure her
back.
So don't put your dancing shoes away yet, you dark little
horse, you. Mummy's not going to let this one drop.

To Geese.

Hello. Quack Quack.

Exit MOTHER.

MARY:

Can I come?

PRINCE:

Don't be ridiculous. You're made of wood.
And anyway. You're too weird.

MARY:

Me weird?

She floors him and hisses. The PRINCE leaves.

GEESE:

You wouldn't believe how they're getting along ong
How could Mr Right look so terribly Wrong ong
And this is the last time we'll sing you this song ong
Ong ong ong ong ong… Hey!

MARY picks up the package with the second dress.

Scene 19: Another Ball

The same drafty village hall.

The PRINCE sits alone. PETER lurks with the dog. Music plays. The MOTHER enters.

MOTHER:
Any sign of her yet?
Put your hat on.

PRINCE:
I'm scared, Peter.
I can't stop thinking about her – I'm aching.
It's going too fast.
I'm opening up like an oyster – and I can't close.
If she doesn't come again I don't know what I'll do.

PETER demonstrates the PRINCE's defensive cricket position.

It's too late for that now, Peter.

PRINCE clasps the ring, PETER clasps penny; they make a wish.

Enter MARY.

You came back.

'Sans Souci' sung by Peggy Lee plays.

PETER tries to dance with MARY.

Sorry, Peter.

PRINCE knocks PETER out. He takes the hat off and tosses it to MOTHER.

Mother. I won't be needing this.
Rex. Stay.

PRINCE and MARY dance. PRINCE kisses MARY. She backs away and wipes her mouth.

.Wait… please… I'm sorry!
Wait – your ring.

She stops.

This is yours. You should have it back.

Mary takes it. She runs away.

Please! Please! I'm sorry! I didn't mean to.

Scene 20: Sick Prince

The PRINCE's bedroom.

PRINCE:
Gone. Gone. Gone. Gone. Gone.
After all these years.
I'll never ever see her again.
She'll never ever ever come back.
It feels like my insides are turning inside out.
I can't breathe.

MOTHER:
Let's have another party.

PRINCE:
I want to die.

MOTHER:
Let me get you a little something to eat.

PRINCE:
Just leave me alone.

MOTHER:
Some toast and Marmite?

PRINCE:
She came back.
I touched her.
I saw her clear eyes.
I held her.

She rested her head on my shoulder
Her hair on my cheek.
and I ruined it.

MOTHER:

What if Mummy made you a little omelette?

PRINCE:

Alright, I'll have an omelette, but please just leave me alone.

Scene 21: The Kitchen

The kitchen.

MOTHER:

He's not a bad boy.
I don't know what I'd do if I lost him as well…
And he did look rather handsome without the hat.
Poor little lamb.
If he has some of Mummy's omelette he'll feel fine!
Now, omelette.
Hang on.
I've never made a ruddy omelette in my life!
What's in an omelette?
Eggs…eggs… Geese!
What's that goose girl called. Sandy? Penny?
Judy!

MARY appears.

MARY:

Mary. Mary Woodenfrock.

MOTHER:

Oh Judy, good. Can you help me? The Prince is unwell.
Can you cook him an omelette for me?

MARY:

An omelette is not one dish. It's five hundred.

MOTHER:
What?

MARY:
Yes. I was once taught to make a good omelette.

MOTHER:
Good. Well get on with it then.

The mother talks to the audience.

Omelette for him. Gin for me.
I can make the best Bloody Mary in Europe but I can't
make a ruddy omelette.
Not something we learnt in my day.
My poor little lamb. I think his heart is breaking.
She's a practical girl, that Judy.
Good old you.

*MARY finishes making the omelette and places her ring in
it. She was going to take it through to the PRINCE, but
the MOTHER takes it off her.*

Very good. I'll take it from here.
Run along. Back to the goose pen.

MOTHER turns back to the PRINCE.

Scene 22: Eating the Omelette

The PRINCE's bedroom.

MOTHER:
Have some of this. It'll make you feel better.

He eats.

That's it. It's nice isn't it?

He bites it and he finds the ring.

PRINCE:
Mother. Who made this omelette?

MOTHER:
 I did.

PRINCE:
 No mother, you didn't. Who made it?

MOTHER:
 Judy. Mary. The wooden girl.

He runs off to find her.

PRINCE:
 Mary Woodenfrock! Mary Woodenfrock!

Scene 23: Girl up a Tree

The goose-run.

The PRINCE is running towards the goose-run calling 'Mary Woodenfrock'. MARY is up the tree, naked, her wooden frock lying at the bottom.

MARY:
 Are you there my ankles?
 Yes you are
 Are you there my thighs?
 You're there
 Are you there my neck,
 My spine, my heel?
 Are you there my hands?
 You are.

 Are you there my elbows?
 Yes you are
 Are you there my crown?
 You are
 Are you there my forehead?
 Yes you are
 Are you there my eyes?
 You are

PRINCE:

Mary Woodenfrock! I found the ring.

MARY:

The very first thing my mother did
Was cradle me in her loving arms
And hug me altogether whole
She hugged me forever whole

The very last thing my father did
Was cradle me in his loving arms
And hug me all apart, he did
He hugged me all apart.

The very last thing my Nurse, she did
Was cradle me in a shell of wood
If she were here, she'd count my limbs
And count them sure and good

Are you there my hips?
Yes you are
Are you there my arms?
You are
Are you there my bones?
Yes you are
Are you there my heart?
You are

The PRINCE climbs the tree and gives her the ring. They sit side by side, talking simply:

My name is Mary.

I grew up in the happiest family. Every day was like a Sunday.
All of us used to play like children.
There was my Mother, my Father, the Nurse and another man called Ronald who looked after the pigeons.
I remember one day we all went to the beach together…

MARY's mother, The DEAD QUEEN, climbs the opposite tower and starts to sing. The company join in.

COMPANY:

Sister, my sister
Lie here beside me
While the cold wind blows
Until the night is gone
Lie here
And I will keep you warm

Sister, my sister
Lie here beside me
While the wild sea roars
Until the night is gone
Lie here
And I will hold your hand

Sister, my sister
Lie here beside me
While the silver moon shines
Until the dawn is come
Lie here
And I will be your eyes

The dress full of stars flies up magically.

MARY climbs down the tree. The story book from Scene 1 flies in. MARY takes it, turns to the PRINCE, places the ring in it and closes it.

The End.

THE RED SHOES
A STORY IN ONE ACT

Foreword: *The Red Shoes*

To write for Kneehigh is an adventure.

To be asked to write a poem that may inspire a vision, a dance, an idea, is a dream commission for me.

This is what I was asked to do for *The Red Shoes.*

One dance was not enough for our heroine, The Girl and one poem was not enough for me. As I wrote they danced their way out onto the page.

We've all seen things we wish we'd never seen and this was to be our starting point; a chorus of characters who had seen horrors they wish they hadn't. For me, it was the memory of stories my grandfather told from the trenches and my father of the landings at Dunkirk.

The mud.

The dirt.

The blood.

Everything in this company's work tells the story: the actors, the set, the music, the costume, the props. A living script grows with Emma and the actors, through devising, improvisation and the poems. Each plays an equal part.

I say living, as it's always changing and we all own it.

Anna Maria Murphy – Writer

Characters

STORYTELLERS

LYDIA

THE GIRL

OLD LADY

SHOEMAKER

SOLDIER

PREACHER

CONGREGATION

JUSTINE

ANGEL / AIRMAN

BUTCHER

PREACHER'S WIFE

The Red Shoes was first performed in 2000 at STERTS, Liskeard, Cornwall, with the following company:

THE GIRL, Bec Applebee
LADY LYDIA, Giles King
THE SOLDIER /
THE SHOEMAKER, Luis Santiago
THE PREACHER /
THE ANGEL /
THE BUTCHER, Mike Shepherd
THE OLD LADY /
THE PREACHER'S WIFE, John Surman

Directed & Adapted by Emma Rice
Designed by Bill Mitchell
Poems by Anna Maria Murphy
Music by Stu Barker
Additional text, The Company
Technician, Lucy Gaskell
Production Manager, Alex Wardle
Set Construction, Sean Stanford & Northern Creative Metal Work
Costumes, Vineeto Gilmore, Karen Brown & Maria Dunaway
Props, Dave Mynne, Sue Hill & Jerry Goodrum
Dance Training, Karen Brown (clog dance), Graham Puckett & Anne Peskett (lindyhop).

Emma Rice – Barclays TMA Theatre Award, Best Director 2002.

The Red Shoes

Four STORYTELLERS enter in grubby vests and pants with suitcases.

They wash their feet, put on their shoes and wait.

A beautiful 'woman' enters. She is a glamorous and glorious transvestite.

Waltz from Masquerade *by Khachaturian plays.*

LYDIA:

My name is Lydia – Lady Lydia.
I am your host – and hostess. Your fisher of fun.
I welcome you from the deepest darkest depths of my
heart to this gorgeous theatre.
Let me lead you through the twisted paths of our tale,
But a word of warning:
for amid the thrills and spills, the twists and the turns,
our story has a bite as well.
Let me bait my hook, I'll cast my line, and together we'll
see what we might catch.

A-one, a-two, a-one, two, three, four…

The band plays.

Oo la la, on commence, let's begin!
Now simmer down, you noisy clapping rabble, for our
story has a sombre start.

There was once a girl:

She chooses one of the STORYTELLERS to play The GIRL.

The other STORYTELLERS clothe her.

Yes, there was once a girl
But not like me.
And she was pretty
And her mother had died.

Yes, her mother had died
Which, in the way of children,
She had not thought possible –
God had lied.
So she was sad
And pretty
Pretty and sad
Pretty sad.

But her shoes (or lack of them)
Let her down,
Which I find often to be the case
(If only folk took more care
Of what they wear).

*The GIRL finds a pot of red paint and a brush. She paints
her feet red and dances gently. She is joined by a family of
rabbits.*

Our Girl with her strange and painted feet,
She's all alone, but so complete.
Now, there came by an Old Lady:

*LYDIA chooses one of the STORYTELLERS to play the OLD
LADY. The other STORYTELLERS clothe him.*

Clickety clack, clickety clack
A wrinkled Cinderella, if ever I've seen one!
Rouched skin,
Ears, the memory of diamonds
Nose used to the scent of money.

One, two, three, four…

Doesn't she drive a gorgeous Bentley?
Chocolate and cream, such a luxurious colour scheme.

Un, deux, trois, quatre…

The OLD LADY drives by in her car.

An Old Lady

Who cried tears of charity
At the thought of such chastity.

OLD LADY:
Lawks-a-Mercy!

LYDIA:
Said the old dear

OLD LADY:
Those shoes …

LYDIA:
Or lack of them…

OLD LADY:
Will never do!

LYDIA:
And she took in our sad and pretty girl.

Ein, zwei, drei, vier..

They drive off together.

The OLD LADY takes off the GIRL's clothes and washes her feet. The STORYTELLERS scrub her clean and change her into a clean vest and pants and a smart black dress. Her old clothes are discarded.

But her feet were still bare!

OLD LADY:
We can't have that!

LYDIA:
said the Old Lady, as blind as a bat.
So she sent for the shoemaker,
Whose pleasure
Was to measure.

LYDIA chooses one of the STORYTELLERS to play The SHOEMAKER.

*The SHOEMAKER calls, measures her feet; and woos the
GIRL with a wonderful pair of Red Shoes.*

Inside her head,
Underneath her curls
There danced a troupe of thoughts
More dangerous than a first kiss
Or imagined bliss.
They danced with chillies on their tongues
And knives at their feet,
Their thighs wet with the sweat of the steps
Mango! Tango! Foreign fandango!

OLD LADY:
Are they smart?

STORYTELLERS:
Yes.

OLD LADY:
Are they shiny?

STORYTELLERS:
Oh yes.

OLD LADY:
Are they black?

Pause.

STORYTELLERS:
… yes.

OLD LADY:
Good. Then let us learn some manners.

The GIRL is taught to sit properly and to darn socks.

She thinks about her Red Shoes.

LYDIA:

> Shoes as red as wounds
> That's what I want.
> Not an orange hue
> Or a vermilion pink
> But red red red
> Kicking under my bed.
>
> Sensible footwear
> Is just too hard to bear.
> Shoes as red as desire
> That's what I crave.
>
> No glass slippers for me
> That turn to skin at the midnight hour
> Shoes that bleed
> That's what I need.
>
> Soles that with
> The Devil have danced
> That's what all you girls need!

Enough, enough!

She claps and the STORYTELLERS run off.

I think our Girl is coming along just fine, so let's turn the gas down a little and let our story simmer. Time passes with a tick and a tock; tick, tock. And while we wait:

one, two, three, four…

The band plays.

I think it's time to elevate the proceedings a little, and there's a girl amongst us who can do just that. It's time to introduce Justine! Justine will now perform for you – the levitation!

Levitation trick.

Thank you, Justine. Back to our story. Now, where were we?

Oh yes. We now see our girl all dressed in white – never really was my colour.

The GIRL is dressed in white, and wears her Red Shoes.

OLD LADY:
Are you smart?

STORYTELLERS:
Yes.

OLD LADY:
Is your dress white?

STORYTELLERS:
Oh yes.

OLD LADY:
Are your shoes black?

STORYTELLERS:
Definitely.

OLD LADY:
Then let us go to Church.

LYDIA:
We're finished now with education
On with preacher, pew and confirmation.

The OLD LADY and the GIRL travel to Church.

The OLD LADY goes in while the GIRL has a last look at her shoes.

Outside the door she meets a young SOLDIER.

Well, what have we here?

Wait a while
Whilst I polish my smile
And flick back my ebony hair.

My eyes are as black as dugouts
My fingers can dance on your flesh.
I can do any step,
What's your request?

(Here on my jacket pocket
Is a space for medals
I've yet to earn.)

For what do you yearn,
As you twist and you turn?
Will you hold my hot hand
When I march off to war?
Be my ever-waiting sweetheart
Before we part?

Let me lick the dust from your shoes
Let their colour shine through
Like pomegranates
Like red eyes crying
Like bull's blood
Like the matador's cloak.

And dance for me,
Dance for me.

SOLDIER:
　　What beautiful Red Shoes.
　　Dancing shoes.

The OLD LADY comes out to collect the GIRL.

The GIRL goes into the Church to take her first communion.

LYDIA:
　　Well the first time she wore them was in the church –
　　where many a blushing bride has been left in the lurch.

PREACHER:
　　Welcome, to the all-embracing, ever-loving arms of this
　　Holy place.

The PREACHER welcomes the CONGREGATION.

The Almighty be praised, for great are the wonders of
his mercy.
Alleluia.

ALL:
Alleluia

PREACHER:
Welcome to the confirmation.

Dear Lord, we say unto You:
How heavy weighs the burden of sin
And we must all humbly atone for our guilt.

LYDIA:
Our heroine's Red Shoes
Kneel before the Virgin
Shining brighter than the bleeding heart.
What a cheek!
Blessed art thou that are meek,
But not you, my girl,
Who wears her heart upon her feet!
Have you seen her shoes?

CONGREGATION:
Have you seen her shoes?

LYDIA:
Her shiny Red Shoes?

CONGREGATION:
Her shiny Red Shoes!

LYDIA:
Red Shoes in the Church!

CONGREGATION:
Red Shoes in the church!
That's disgraceful! etc

The hubbub rises until the PREACHER says:

PREACHER:
Amen.

LYDIA:
The priest stumbles over scripture, and Hellfire burns in the heads of those bent in prayer.

PREACHER:
Dear Lord
Help us to tread the righteous path
The straight and narrow…

LYDIA:
And now our heroine
Walks boldly to the altar
(Trying desperately not to falter!)

PREACHER:
Dear Lord,
We must resist temptation.
Dear Lord, punish those who are weak:
Cast them into the bottomless pit.

LYDIA:
Out pops her tongue
As pink as raspberries, ready
To receive the Body of Christ.

PREACHER:
Dear Lord, we ask you to allow this sweet child
to partake in the body of – …Christ!!!

LYDIA:
Outside the soldier sits and whistles a tune through the tunnels in his teeth, and our heroine feels her feet begin to…twitch.

The PREACHER is horrified at the sight of the GIRL's Red Shoes and throws her out of the Church.

PREACHER:

Let discipline be your disciple.

PREACHER exits.

Outside the GIRL dances with the SOLDIER.

LYDIA:

Be careful sweet love – the old dear is on the lookout.

The GIRL seduces soldier with her Red Shoes.

SOLDIER:

What beautiful Red Shoes. Dancing shoes.

Dance music starts.

The GIRL finds that she cannot stop dancing.

The OLD LADY appears.

LYDIA:

Oh dear – she's not going to like this one little bit.

The OLD LADY wrestles with the GIRL, trying to stop her dancing.

She finally manages to pull the shoes from her feet. Both are exhausted.

OLD LADY:

Never, ever, never wear Red Shoes in Church!
We'll put them away and never look at them again.

They get up wearily and start to walk home.

The OLD LADY collapses in the GIRL's arms.

LYDIA:

Enough, enough!

LYDIA claps her hands and the STORYTELLERS run off.

Let's draw a curtain around this troubling scene.

Our Girl's youthful ways seem to be taking their toll on the Old Lady's health.

And those red, Red Shoes. They're very obsessive, aren't they?

One has to ask the eternal question:

Can we ever escape our obsessions?

Well, I don't know, I honestly don't have the foggiest.

But there is a girl who might be able to help us.

Yes, ladies and gentlemen:

it's time for more of Justine!

Justine will now perform for you:

The Escapologist!

JUSTINE is tied up in a sack and tries to escape. She can't.

Well there we have it... Martha just get her out of that bloody bag.

It really is pathetic seeing her all trussed up like that, in canvas. One doesn't know whether to feel pity or...or jealousy.

JUSTINE is released. There is applause.

Order, order! Can we show some respect, please?

If you will remember, shadows are looming:

sickness has visited the Old Lady's house and those red, Red Shoes are out of sight, out of mind. Perhaps.

We see the OLD LADY being nursed by the GIRL. She is obviously close to death, but the GIRL's thoughts keep returning to her Red Shoes.

Shoes as red as wounds that's what you want. Not an orange hue or vermillion pink but red, red, red...

Shoes that bleed that's what you need; soles that with the devil have danced, that's what girls need.

She sneaks onto the OLD LADY's bed, reaches up to the high shelf, takes them down and slips out of the house.

Alone at last! Go on, give in!

The GIRL puts on her Red Shoes and begins to dance: Slow Groove into 4/4 Clog Dance.

She dances off on a journey.

Over hill and over dale
Our Girl now starts to blaze a trail.
Over dale and over hill
Our headstrong Girl just won't keep still.

The GIRL sits with LYDIA.

At first it was the slow step
When her feet began to twitch
She danced on the face of Jesus
And Tango-d on his bones.

Her heart it went jitterbug
And her head, it did a reel,
She shimmied on a gravestone
(she just didn't want to stop)
She Charlston-d over lovers
Until she was fit to drop!

She twisted more than a waterspout
And Hornpiped with the wind,
She stripped the willow with an oak tree
And Samba-d over the hillside
As far as the eye can see.

And all without a partner
I've never seen the like.

Moonlight, starshine, music…
Time has passed.
Let's see who now returns.

The GIRL comes across the SOLDIER. He has been to war, he is wounded and shell-shocked. They dance. She terrifies him with her violent dance.

The SOLDIER leaves, in distress. The GIRL tries to take off her shoes. She can't.

Well, try as she might
They just won't budge
Stuck to her like a grudge.

She went like hell for leather
She shook her feet like a wet dog
Trying to relieve the pain –
But it was all in vain.

She dances the Can-Can and then journeys on. The GIRL as doll enters.

Here she comes!

Oh Martha she's lovely – look at her long hair.

Over hill and over dale,
Our Girl is getting very pale!
Over dale and over hill,
Our unlucky girl just can't keep still!

The GIRL goes to the Church doors.

And as her skin went chicken-leg
To the Lord she did beg.

The GIRL tries the Church doors but they are locked.

She knocks.

I opened my eyes and looked up to the skies… And all about me were Angels.

The ANGEL / AIRMAN opens a small door.

ANGEL:
Hello… I'm terribly sorry but I'm not receiving you. You seem to be in a flat tailspin. I recommend you find yourself some clear airspace – you can't come in. Roger, Wilko, over and out.

She knocks again.

Look, I'm on reconnaissance and I can't be diverted and I won't authorise any form of crash-landing. Charlie, chicken-feed, Roger, Wilko, over and out.

She knocks again.

You leave me no option but to curse you. To curse you to damned eternity. You must dance forever in those Red Shoes of yours until your skin hangs off your bones and you are no more than entrails dancing, and when all others see you, they will be afraid…afraid of your fate for themselves. So consider yourself shot down in flames over enemy territory. Roger, Wilko – over and out.

Funky music starts.

LYDIA:
Unlike Jesus' loving arms
The doors of the Church wouldn't open
So,
Tormented by the soft sound of choirs singing psalms,
She danced on.

The GIRL sits still outside the doors of the Church but her feet still dance a Clog Dance.

Dance, dance wherever you may be,
I am the Lord of the Dance, said he! –

Here she comes!

Puppet journey in the distance.

Oh Martha whatever's happened to all her lovely long hair?

JUSTINE enters with scissors.

JUSTINE and MARTHA fight.

Justine you wicked girl!

Look will the two of you just pack it in?

Over dale and over hill
Our Girl is looking very ill!
I blame her choice of shoes, I really do:
You see mine? They're just divine!
Now everybody, you stay there,
Come on Martha – we're all late for an appointment at
the Church.

We stumble upon a sad scene: The OLD LADY's funeral.

PREACHER:
Cut that disgusting row!
This is a sombre occasion.

LYDIA:
Oh dear me
And now we see
The Old Lady's last breath
Turn to mist
On the face of Mister Death
And like a newborn,
We hear a rattle,
Not clutched in an infant's sticky hand
But shaken in the old dear's final battle!

PREACHER:
Dear Lord above, we ask you in your mercy to take this
frail bag of earthly bones up into thy celestial
kingdom...

*The GIRL starts to dance the Charleston. The PREACHER
is horrified.*

LYDIA:
On and on she danced,
Even after the petals were thrown
Sending the Old Lady into the unknown.
She danced all the way to the Butcher's door

Her breath fast and her feet sore.

The BUTCHER enters and hangs rabbits.

And here is the Butcher,
He's a kind and simple man
For all that severed flesh.

BUTCHER:
Right let's be having you rabbits – that's a fine rump of
rabbit. Now for a sweep up – get rid of all this blood and
guts and offal… There we are – all spick and span, ready
for another day.
Well what have we here?
Hello my dear, how may I be of assistance, my darling?

*The GIRL grabs the BUTCHER's knife and tries to cut her
feet off. He stops her.*

LYDIA:
Just cut them off! she went
Let them dance alone.

BUTCHER:
Cut them off?
A tender cut of calf, a perfect loin of pork, a sheep's
heart –
Easy to impale.
But a living, breathing female?

LYDIA:
He was hardened to a lamb's bleat,
But a young girl's feet?

BUTCHER:
Now then listen to me…
I can see you're in some distress, but…

*The GIRL grabs the knife again and tries again. He prevents
her*

LYDIA:
> Look at me…
> It has to be done.

BUTCHER:
> Alright then my lovely, let's have you up on the block.
> Come on – the butcher's a very strong man…used to
> lifting carcass all day.
> Now this here's a tourniquet; you might experience some
> numbness, but it's mainly to stem the flow of blood.
> Bite on your hand if it's hurting.
>
> Try to keep as still as you can, I'm just going to make
> the first cut. That's a lovely clean cut. I can part the flesh
> and see the bone.

LYDIA:
> Used to watching pigs bleed, this was a very strange cut
> indeed.
> I think we should all take a closer look…
>
> *The doors close.*

BUTCHER: (*From behind the doors.*)
> Now – I'm just going to saw part way through the
> bone… (*Sound of sawing.*)… That's one done… (*More
> sawing.*)… There, that wasn't so bad was it? Now one last
> chop – good and clean so as not to splinter the bone…
>
> *Sound of chop and a scream. The dreadful sight is revealed.*
>
> It had to be done!
> Don't worry my love, I'll soon set you straight –
> I'll make you a lovely pair of wooden feet!
>
> *The doors close again as the BUTCHER works away.*

LYDIA:
> Well chip chip, chop chop he went with some old
> carving chisels.

Chip and chop – he's very quick you know. Oh look – wood shavings! Chip chip… Do you know, I think he's finished!

The doors open again to reveal the GIRL standing unsteadily on her wooden feet.

BUTCHER:

There, my darling, a lovely pair of wooden feet! Oh, you're a bit unsteady aren't you? Here you are – use this. And two makes a pair…

The BUTCHER gives her two brooms to use as crutches and she hobbles away.

Take a step or two… Right, left… right… Oh you're doing ever so well – oh mind the step! There, let me help you down… The butcher's a very strong man. Now off you trot.
Oh, don't you worry about them, that's just a silly old pair of chopped-off feet…
It was lovely to see you… Give my very best regards to your mother… Oh I'm sorry, I clean forgot, she passed away.

The BUTCHER washes his hands and starts to clear up.

The severed feet start to move by themselves.

Lord! Forgive me for what I have done!

LYDIA comes down from the gantry.

LYDIA:

Lord, forgive me for what I have done…

The severed feet move towards LYDIA.

The STORYTELLERS run off and re-enter and sing unsteadily.

Lights! Lights! I need my lights! Please… Please…

The lights come up.

Enough, enough!
We must forge on.
On to her fate, and ours. We, who can only remember.
We find ourselves back at the Church.

The PREACHER preaches to the chosen few, God's children.

In the background we see the PREACHER's WIFE.

See our Preacher's wife:
She's obedient, devout, attentive.

The GIRL arrives back at the Church.

And over there, our Girl returns
Not so sure-footed now
To the Church
Doors shut, like the tight lips of the righteous.

The GIRL knocks on the Church door.

Rat-a-tat-tat, she knocks:
Let me in, I've danced my last
But the faithful cast their eyes aghast,
For still she leaves a trail of red,
Like rubies, like cherries, like Christ's Holy berries.

*The Red Shoes appear and haunt The GIRL, preventing her
from entering the Church.*

Again and again she knocks,
But not a turned head
Except for the Preacher's Wife,
Whose own life was full of strife.

PREACHER'S WIFE:
 Come, my child.

LYDIA:
 Said the Preacher's Wife,
 Seeing she was fresh from the Butcher's knife.

PREACHER'S WIFE:
 Work is your salvation,
 Take it from me.
 You must sweep, sweep, sweep
 Until you weep, weep, weep.

LYDIA:
 Sweep and weep, sweep and weep.
 Cleanliness is next to Godliness.
 A clean house is a clean mind.

 They start to sweep together.

 The PREACHER intervenes.

PREACHER:
 Wife!

PREACHER'S WIFE:
 Our new servant!

PREACHER:
 A sinner!

PREACHER'S WIFE:
 In need of salvation!

PREACHER:
 Home, wife!

PREACHER'S WIFE:
 Yes, dear.

 *They leave the GIRL sweeping, but again, she is tormented
 by the Red Shoes.*

LYDIA:
 And so she swept
 And she wept
 Till every speck of dust was airborne
 Floating like thoughts,
 Like dreams

Or so it seemed.
And now with every last brush
Her soul cried out
Let me in! Let me in!
I know I've waltzed with sin!
And to her knees she fell,
Oh save me, save me!
I know I've danced to the very gates of Hell!

When she has truly repented, the ANGEL comes to collect her.

I opened my eyes, I looked up to the skies
And all about me were angels.

ANGEL:
It's over.
Come with me.
Up into the blue.
Heavenward.

LYDIA:
It's over.
Up into the blue.

He leads her away but she falters. It is as if she has remembered something: herself.

She breaks away.

ANGEL:
Now come along, your place is booked.
Salvation is yours.
Come along… Heaven.

I'm afraid I must insist.

She breaks away again and a vicious fight ensues.

She beats the ANGEL and goes her own way.

LYDIA is left standing alone. She starts to undress.

LYDIA:

Well some say she danced to the very gates of hell,
But I don't think so.
Not me.

I, who have seen things that should never have been
seen,
Been to places I should never have been;
I, who have known despair
And seen souls beyond repair.

These hands... these hands have been encrusted in filth
And there are some things that can never be washed
away.
I stand here now, in the flesh
And my secret's reserved for those
Who dare to dance a different dance:
With me.

LYDIA is now a man dressed only in vest and pants, like the others.

The Khachaturian Waltz *plays and the STORYTELLERS dance.*

The End.

CREDITS

Writers' Biographies

Emma Rice Writer and Adaptor
Emma trained at the Guildhall School of Music and Drama
and the Gardzienice Theatre Association, Poland. She has
worked extensively with Kneehigh Theatre, Theatre Alibi and
Katie Mitchell. Choreography includes projects with the RSC,
Welsh National Opera, Northern Stage and West Yorkshire
Playhouse. Direction includes *The Itch, Pandora's Box* (co-
produced with Northern Stage), *Wild Bride* (The Shamans,
Budapest), *Tristan & Yseult, The Wooden Frock,* nominated for
Best Touring Production 2004 TMA Theatre Awards, *The
Bacchae,* and *The Red Shoes* for which she won Best Director
2002, Barclays TMA Theatre Award. Emma has recently
become Artistic Director at Kneehigh Theatre.

Carl Grose Writer
Carl has performed in many Kneehigh shows including *The
King Of Prussia, The Riot, Pandora's Box, Skulduggery* and *Quick
Silver,* which he also wrote. Other writing credits for the
company include *Tristan & Yseult, The Bacchae* (with Anna
Maria Murphy) and most recently *Wagstaffe The Wind-Up Boy*
(with Mike Shepherd). He has also written for Plymouth Theatre
Royal, BBC TV and Radio. He co-founded Cornish production
company o-region, which produced his short films *Wormy Close*
and *Kernow's Kick-Ass Kung Fu Kweens.* He is currently working
on a new play, *49 Donkeys Hanged,* for the National Theatre
Studio.

Anna Maria Murphy Writer
Anna first started writing for theatre to avoid playing a dog in
a Kneehigh 'Wild Walk'. Writing for the company includes
*The Bacchae, The Red Shoes, Tristan & Yseult, Skulduggery, Doubtful
Island, Ghost Nets, Women Who Threw the Day Away, Telling Tales,
Wild Bride* (The Shamans) and the film *Flight.* She has also
written for Theatre Alibi, Platform 4, Brainstorm Films, The
Eden Project, and with Scavel an Gow for Radio 4.

Tom Morris Writer

Tom Morris is Associate Director at the National Theatre. Work as a director includes *Passions, Othello Music, Trio, Oedipus the King, All That Fall, Unsung, The Kombat Opera Klubneit, Macbeth* (with Corin Regrave), *Disembodied* (with David Glass) and *Newsnight The Opera*. Writing includes *Ben-Hur, Jason and the Argonauts* and *World Cup Final 1966* (with Carl Heap) and *The Wooden Frock* (with Emma Rice). Producing includes the programme of BAC, where he was Artistic Director from 1995–2004.

Management Team

Artistic Director	Emma Rice
Company Director	Mike Shepherd
Associate Artist	Bill Mitchell
Production Manager	Alex Wardle
General Manager	Victoria Hutchinson
Finance Co-ordinator	Ali Firth
Tour Co-ordinator	Sarah Leigh
Marketing & Publicity	Laura Eastwood

Kneehigh Theatre

14 Walsingham Place
Truro
Cornwall
TR1 2RP
Tel: 01872 267910
www.kneehigh.co.uk
office@kneehigh.co.uk